Illuminated Manuscripts
from Belgium and the Netherlands

IN THE
J. PAUL GETTY
MUSEUM

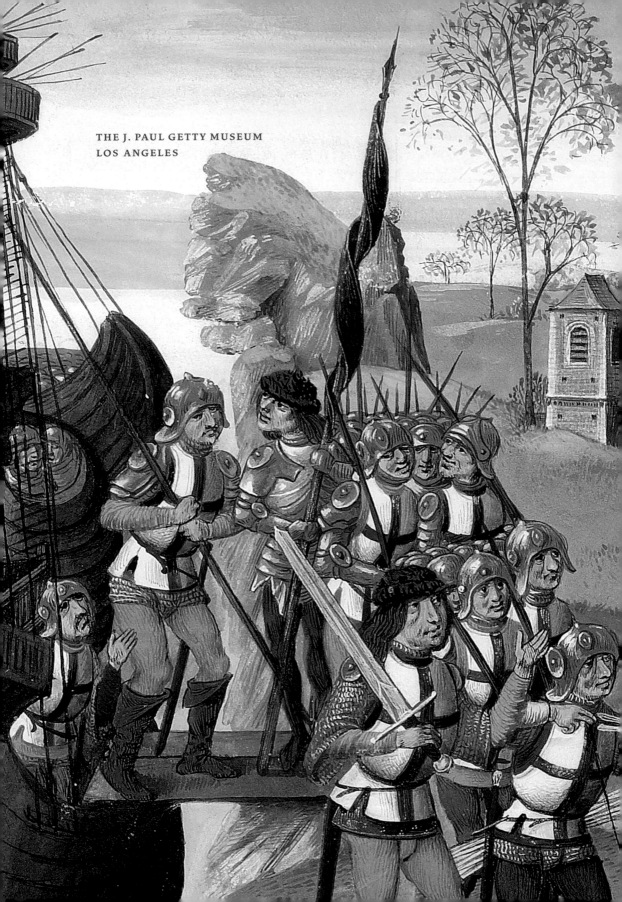

Illuminated Manuscripts from Belgium and the Netherlands

IN THE J. PAUL GETTY MUSEUM

Thomas Kren

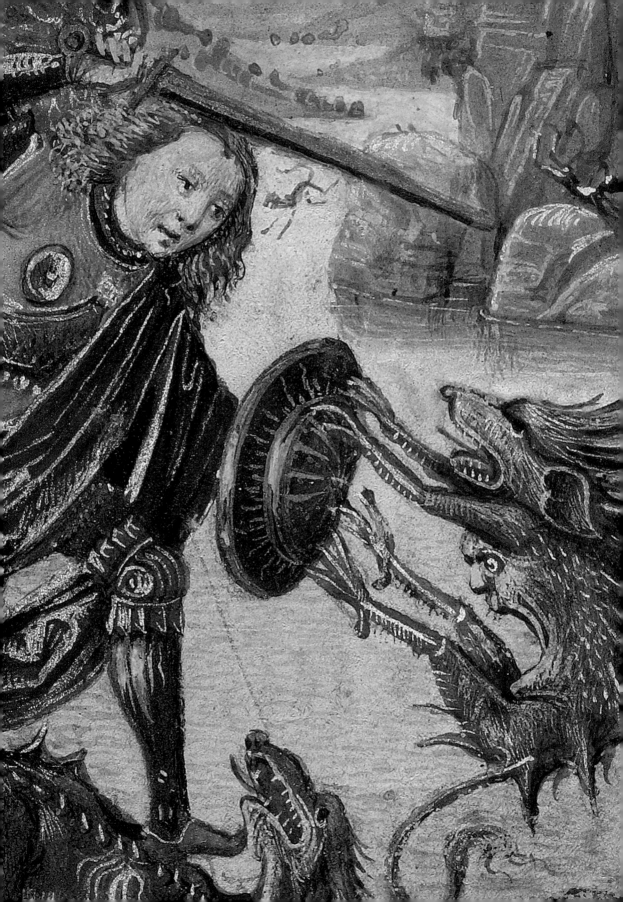

FOREWORD

The fourth volume in the pictorial survey of the J. Paul Getty Museum's ravishing collection of illuminated manuscripts introduces medieval book illumination from Belgium and the Netherlands. These works, in particular the splendid illuminations of the Burgundian Lowlands in the fifteenth and sixteenth centuries, are a highlight of both the manuscripts collection and the Museum as a whole. The thirty manuscripts from this region include a group of masterworks by the leading illuminators of the day: the Prayer Book of Charles the Bold, illuminated by Lieven van Lathem for the Duke of Burgundy, 1469; *The Visions of Tondal*, illuminated by Simon Marmion for Margaret of York, Duchess of Burgundy, 1475; the Spinola Hours, 1510–20, considered by some to be the most important Flemish manuscript of the sixteenth century; the Brandenburg Prayer Book, illuminated by Simon Bening for Cardinal Albrecht of Brandenburg, 1525–30; and *Mira calligraphiae monumenta* (*Model Book of Calligraphy*) that Georg Bocskay wrote out for the Holy Roman Emperor Ferdinand I in 1561 and 1562 and that was subsequently illuminated by Joris Hoefnagel for Rudolf II during the 1590s.

I am indebted to the many Getty staff members and others who contributed to the publication. Thomas Kren, Senior Curator of Manuscripts and a specialist on manuscripts of the Burgundian Lowlands, compiled this volume. Independent scholar Catherine Reynolds as well as Anne Woollett and Erin Donovan of the Getty Museum's curatorial staff each gave the text a critical reading and made many useful suggestions to the author. The Museum's Imaging Services Department, in particular, Rebecca Vera-Martinez, Johana Herrera, Michael Smith, and Stanley Smith, collaborated closely to produce the highest quality digital files of the illuminations illustrated here. Beatrice Hohenegger, Amita Molloy, Jeffrey Cohen, Karen Schmidt, Deenie Yudell, and Ann Lucke of Getty Publications, as well as manuscript editor Robin Ray, all worked conscientiously to make this book as handsome and useful as possible.

David Bomford
Acting Director

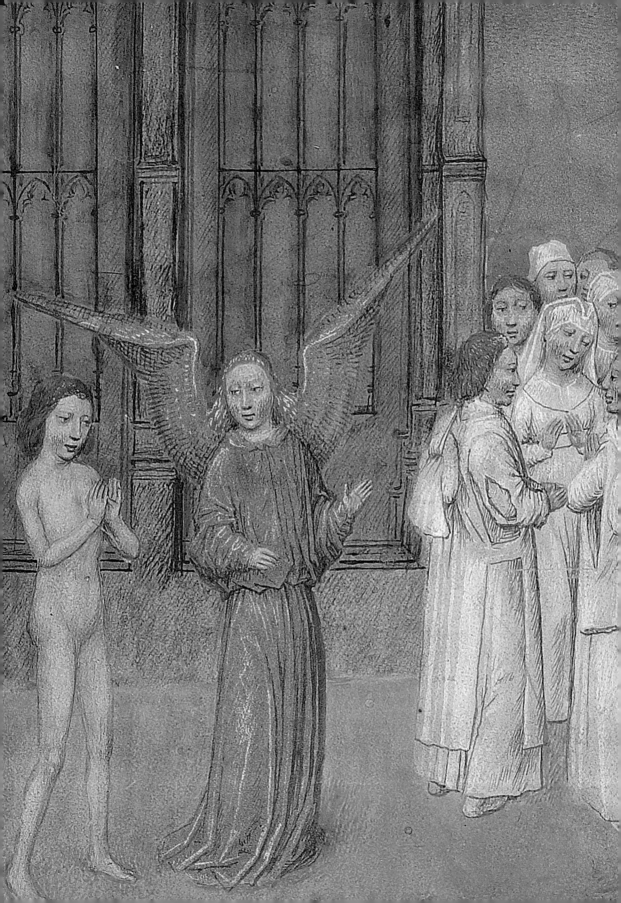

INTRODUCTION

The legendary splendor of the court of Philip the Good
(r. 1419–67), duke of Burgundy, was expressed in magnificent banquets, tournaments,
triumphal entries into towns, and meetings of the Golden Fleece, the chivalric order
he founded. Ducal patronage of tapestries, paintings and decorations, and plate and
other metalwork supported court ceremony. Further costly and ambitious patronage
included the chronicling of the ducal reign and the compiling of the histories of
individual territories, volumes—often splendidly illuminated—meant to find their way
into the magnificent ducal library. Indeed when the duke died in 1467, several of his
luxurious commissions for illuminated histories were left unfinished. One of these,
Histoire de Charles Martel (*History of Charles Martel*; Brussels, Royal Library of Belgium),
represented by fifteen miniatures in the Getty's collection (pp. 65–67), consisted
of four large volumes of text, more than four thousand pages, which had been written
out by the court scribe David Aubert (act. 1449–79) between 1463 and 1465. However,
much of the work's intended decoration, including more than one hundred miniatures
and many more finely illuminated initials, remained to be painted. Philip's son and
heir, Charles the Bold (r. 1467–77), saw to the book's decoration. He hired Loyset Liédet
(act. 1460–79) to paint the miniatures and paid him upon their completion in 1472.
This extravagant book is emblematic of the extraordinary political and artistic legacy
of the elder duke, whose domains had come to include most of what is now Belgium
and the Netherlands, along with parts of northern France. His territorial and dynastic
ambitions transformed the map of Europe.

 Philip's patronage of art and culture, including the library of more than seven
hundred volumes, made him a model Renaissance prince. He personally commissioned
more than sixty books, including historical chronicles such as the *Martel* that supported
his dynastic and territorial claims, along with romances, theological treatises, devotional

books, and other religious writings. The duke's library was an expression of the man as a Christian prince and the embodiment of the state—his politics and authority, his learning and piety. Moreover, ducal patronage helped transform the healthy but comparatively provincial industry of manuscript illumination in the Lowlands, where Philip strongly focused his dynastic ambitions from the 1420s, into one that came to dominate Europe for several generations.

 Illuminated Manuscripts from Belgium and the Netherlands describes the holdings of the J. Paul Getty Museum in the area of Netherlandish manuscript illumination. Most of these works were created during the period of rule of the Burgundian dukes and their Habsburg heirs. The duke's remarkable patronage stands as the pivotal cultural event for understanding the story of Netherlandish manuscript illumination represented by the collection. The following account will examine the tradition leading up to Philip's own bibliophile activities, the exceptional flowering of manuscript illumination that commenced during his reign, and the significant ways in which it endured for several generations after his death. The reader should note that we do not always know the names of illuminators, who rarely signed their works. The names of convenience that appear here (such as the Master of the Dresden Prayer Book) have been assigned by scholars, usually based on an important book that the artist illuminated or a painting he painted.

 The story of manuscript illumination in the Lowlands begins well before the time of Duke Philip the Good, indeed even before the first Valois duke of Burgundy, his grandfather, married the daughter of the count of Flanders in 1369. The prior history of the county of Flanders, an area today spread out over much of western Belgium and significant portions of northwestern France, helps to make clear the eventual attraction of the region for the Burgundians. This earlier period, while modestly represented in the Getty collections, sets the stage for the momentous artistic developments of the fifteenth century.

 Following the Norman invasions in the ninth and tenth centuries, there was a slow but steady return to economic prosperity in Flanders, a region that then included such towns as Ypres, Tournai, Ghent, and Bruges. The fates of these cities were much intertwined in the High Middle Ages. In the eleventh and twelfth centuries the

emergence of the textile manufacturing industry, centered on the wool trade, spurred regional growth, with Flemish cities as the engines of production. These same centuries saw widespread monastic reform and an increase in the number and prominence of abbeys and monasteries, some achieving considerable independent wealth. These religious institutions were the centers of learning and also patrons of artistic production and architecture: churches and their furnishings; liturgical objects, including lavishly illuminated manuscripts; and libraries with theological, devotional, philosophical, and other texts, most often with Christian content.

An important monastic activity in this time was not only the writing of new texts but even more the copying and transmission of both new and venerable older texts. As a result, images of writing monks, clerics, and scribes often appear in illustrated books, among which illuminated lives of saints and historical texts enjoyed particular popularity. Two miniatures in a twelfth-century copy of *De vita et conversatione Anselmi Cantuariensis* (*The Life and Conversations of Saint Anselm of Canterbury*) in the Getty collection (pp. 38–39) show the author, Eadmer (ca. 1060–ca. 1130), composing this biography. Anselm (ca. 1033–1109), one of the great intellectuals of his time, is still read today for his ontological argument for the existence of God. Eadmer was himself a cleric, Anselm's chaplain and secretary, and hence well situated to author such a biography. One of the miniatures of Eadmer writing (p. 39) shows the monumentality that Romanesque artists strove to achieve: the tall, broad figure, seated with authority on an elaborate stool, nearly fills the architectural niche where he labors on the text. His chasuble and surplice are trimmed in gold, underscoring the author's eminence.

The twelfth century witnessed a great flowering of manuscript illumination in southern Flanders, especially in Benedictine monasteries during the second half of the century. *The Life of Saint Anselm* belonged to the Benedictine monastery of Saint Martin at Tournai as early as the seventeenth century and may have been made for it originally. Its images of monks writing share compositional features with manuscripts produced at the Abbey of Saint-Amand, a prominent center of book production just south of Tournai (today over the border in France).

In towns such as Ghent and Ypres, the wool industry developed as early as the eleventh century. Ghent reached a commercial peak in the thirteenth century,

manufacturing more wool cloth than any other European town by the second half of the century. The need to import raw wool and export finished cloth encouraged Bruges, situated in a strategically important location closer to the North Sea, to connect with international trade routes. As a result it emerged as a major trading center by the end of the twelfth century. With the establishment of these towns as centers of wealth, and the concomitant rise of an urban, merchant class, it was perhaps inevitable that some of them would become centers of artistic production as well. Bruges and Ghent produced luxury manuscripts, such as costly illuminated psalters, for the new bourgeois merchant class as well as for the court of the Flemish counts. While manuscript illumination is often viewed either as a monastic or a court art—many of the manuscripts represented in this book were actually made for a ruler, a member of his family, or of his court—during the twelfth and thirteenth centuries, the newly rich merchants of Ypres, Ghent, and Bruges also achieved political power within their communities and began to accumulate cultural markers of their new status. The private ownership of a prayer book enabled individuals to express their religious devotion; a richly illuminated psalter also indicated their wealth, taste, and social position. By the middle of the thirteenth century, Bruges was producing the finest illuminated psalters in the Lowlands. Although its precise place of production is harder to pin down, the Getty's Flemish psalter, from about 1250, was clearly inspired by Bruges illumination and also shows resemblance to manuscripts produced in Ghent. Its illuminator's rendering of figures and movement is informed by firsthand observation of the physical activities of men and animals, reflecting the burgeoning naturalism of Gothic illumination found in the same years in Paris, the greatest center of illumination at the time. Especially noteworthy are the hunter's handsomely caparisoned galloping horse illustrating the calendar for May (p. 40) and the violent gestures of the soldier tormenting Christ at the right in *The Flagellation* (p. 41). The artist shows us the muscles of the flayers' calves and even the flushed face of the tormenter on the right, who turns away from the viewer and from Christ in a culmination of the vigorous, twisting movement that engages his entire body. The cycle of seven full-page miniatures, ten large historiated initials, and twelve calendar miniatures in this manuscript shows how luxurious psalters from this region could be. Some were more lavish still.

The interest in nature characteristic of the High Middle Ages is also evident in the proliferation of bestiaries, collections of lore about individual animals whose behavior was often interpreted allegorically within a Christian world view (pp. 43–47). Illuminated bestiaries were widely popular in western Europe and England in the twelfth and thirteenth centuries, and the Getty owns an exceptionally beautiful copy produced in Flanders around 1270. The chapter on the lion draws upon the biblical account of Samson wrestling with that beast (p. 44), illustrated by Samson's powerful motion as he forces open the lion's jaws. We would characterize the bestiary today as pseudoscience, due to its lack of modern scientific method, but also for its inclusion of apocryphal creatures such as the siren and the centaur (p. 45). Both are hybrid figures, one half-woman, half-bird, the other half-man, half-horse. In classical mythology, sirens were thought to lure sailors to their deaths with their song, and the bestiary held them up as symbols of worldly temptation. Here a siren vainly admires her beauty in a mirror. The centaur represented the zodiacal sign of Sagittarius; in the bestiary it also symbolizes hypocrisy.

These two books give an idea of the vitality of Flemish manuscript illumination in the thirteenth century as well as revealing the firm foundations of a tradition that would continue to grow in quality and significance. Despite diverse economic and political upheavals over the course of the next century, Bruges and Ghent remained important economic centers and also centers of illumination. Two developments held considerable importance for the future of the region: the marriage of Duke Philip the Bold of Burgundy (r. 1363–1404) to Margaret of Mâle, daughter and heiress of the count of Flanders, in 1369, and the expanding role of Flemish towns in the export of luxury goods, especially, by the end of the fourteenth century, illuminated prayer books from Bruges. The marriage gave the duke and his heirs sway over the economic powerhouse of Flanders, located a great distance both geographically and economically from Burgundy, their largely agricultural dominions in France—best known even then for its wines. Philip the Bold was himself a bibliophile and the brother of the Valois King Charles V of France (r. 1364–80). Charles established a model of princely bibliophilia in northern Europe through the accumulation of a library of 1,150 volumes, many splendidly illuminated. Through his patronage he helped to maintain Paris's preeminence in

the field of illumination. Thus, the marriage of Philip and Margaret not only was an auspicious union on a political level, laying the foundations for one of the most powerful states of the later Middle Ages, but also on a cultural level, joining the Valois taste and passion for book collecting with the Flemish tradition of artistic creativity, industry, and manuscript production. This cultural fusion did not bear fruit as rapidly as the political one, but its effects were arguably as lasting and historically important.

By the time of Philip the Good's death in 1467, much of the geographical region of the northern and southern Netherlands had come under Burgundian rule or influence, including Brabant, Hainaut, Holland-Zeeland, Utrecht, Guelders, and Liège, but as with the county of Flanders, many of these areas had developed their own traditions of manuscript illumination. For example, Albrecht, Duke of Bavaria, first became regent, then count of Holland, Zeeland, and Hainaut (r. 1389–1404). With Margaret of Cleves, his second wife, he established a court that patronized new construction, painting, literature, manuscript illumination, and music. In 1385 his son William wed a daughter of Philip the Bold.

One of the anonymous workshops of artists that flourished in this environment and under Albrecht's son, William VI of Bavaria (r. 1404–17), is known as the Masters of Dirc van Delf. A book of hours—a private devotional book—from about 1405–10 is one of this workshop's masterpieces and offers an indication of the emerging brilliance of manuscript illumination in the region. Artists of the late fourteenth and early fifteenth centuries in northern Europe introduced a new level of pathos to devotional images, emphasizing the humanity of Christ and his actual suffering during his persecution and subsequent death on the cross. In the miniature *The Betrayal of Christ* (p. 48), he is shown as a figure more saddened than shocked by Judas's betrayal in the Garden of Gethsemane. He even raises his hand calmly in blessing amid the tumultuous events engulfing him, including the figure of Peter, on the left, preparing to cut off the ear of the servant Malchus, who has collapsed to the ground, dramatically spilling out of the frame toward us. In *The Entombment of Christ* (p. 49), the tender expressions on the faces of the Virgin Mary, Joseph of Arimathea, and Nicodemus are meant to evoke comparable emotions of compassion and regret in the devout user of this book. In such devotional miniatures, details of setting are largely eliminated to focus

the viewer's attention on the story and its spiritual meaning. They are images intended to foster private meditation.

The Burgundian dukes were patrons not only of manuscript illumination but of sculpture, architecture, and other media. Under their patronage, Jan van Eyck of Bruges (ca. 1395–1441) elevated the art of painting in oil on panel to a new, exalted level of refinement with extraordinary effects of light, color, and texture. Philip the Good appointed him court painter in 1425. Van Eyck, who may also have illuminated manuscripts, exploited the translucency of light and density of color achievable in oil on the smooth, hard surface of wood to surpass even the jewel-like qualities and naturalism already evident, for example, in Parisian manuscript illumination of the early 1400s (see also in this series *French Illuminated Manuscripts in the J. Paul Getty Museum*, 2007). A vivid echo of what he achieved as an oil painter is evident in the miniature *Christ Blessing* (p. 50), a leaf removed from the Turin-Milan Hours (Turin, Museo Civico d'arte antica). This famous book of hours contains the suite of illuminations that most faithfully captures the spirit and qualities of Eyckian painting. Here the head of Christ is closely based on a lost painting by Van Eyck, especially in the hair, which displays an astonishing level of detail, subtlety of color, and softness of light. In the background behind the figure, the exquisite tooling of gold leaf and tiny squares of rich color, arranged in a fine checkerboard pattern called diapering, demonstrates the ever-increasing sophistication of Flemish manuscript painting by the middle of the fifteenth century. Delicate rays of light, painted over the diaper pattern, define a halo behind the head. The artist of this miniature may have learned these extremely refined techniques in the studio of Van Eyck. The Llangattock Hours, another devotional manuscript from midcentury produced in Bruges, also draws heavily on Eyckian models. *The Annunciation* (p. 53) translates the figures of Gabriel and the Virgin from Van Eyck's own *Annunciation*, set in a church interior (Washington, D.C., National Gallery of Art), to a prosperous fifteenth-century urban home.

At the beginning of the fifteenth century, Paris remained a magnet for the finest artists across Europe even as Bruges had firmly established an international market for illuminated devotional books produced locally. Talented artists from the Netherlands, such as the Limbourg Brothers from Guelders (act. ca. 1400–16), Jacques Coene from

Bruges (act. 1398–1404), and an anonymous Flemish illuminator called the Master of Guillebert de Mets (act. 1420–50) headed to Paris as adolescents or young men for both training and lucrative commissions. The Getty owns a masterwork by the last of these three, a book of hours painted when he had settled in Ghent toward the end of his career but was still using the models of leading Parisian book illuminators such as the Boucicaut Master (act. 1400–20). The artist gives a luscious, fairy-tale setting to the story of Saint George defeating the dragon (pp. 15 and 54), thereby saving the life of a Christian princess shown in the foreground. His illumination, with its dwarf trees, turreted castle, and argentine skylines (literally painted in silver), was inspired by early fifteenth-century Parisian models. The Master of Guillebert de Mets inserts a humorous note—the frightened king and queen peering out of the tower in the left margin—but also a personal flourish that would exert a great deal of influence on Flemish manuscript illumination: the curling acanthus leaves and thick vines that vividly wend their way through the border. They seem to be growing and expanding on the page; to a modern viewer their massive pods look forward to the classic film *Invasion of the Body Snatchers*, but for the fifteenth century they asserted a new presence, both more tactile and more substantial, in the decorative motifs of the border.

Saint George embodied the physical bravery, Christian morals, and courtly values of the medieval knight that the Burgundian court held especially dear. Philip the Good, who stewarded the expansion of Burgundy through a policy of territorial acquisition by every means at hand—inheritance, purchase, intrigue, treaty, and military conquest—founded his own chivalric order, the Order of the Golden Fleece, to honor the duke's noblest knights and foreign allies and, especially, to bind the latter to his rule. Philip the Good forsook the ducal residence in Paris for the towns of the Lowlands, spreading his administrative centers among them and establishing a peripatetic court. In the process he fashioned an influential model of the state and its court by exploiting the arts for effect, ruling by pomp and ceremony. The ducal banquets, tournaments, joyous entries into towns, and other celebrations not only expressed the wealth, power, and splendor of the Burgundian court but also were well matched with the strong local tradition of festivals in the Lowlands. The extravagant surcoat of Saint George reflects the prominent role of costume in court life and ceremony; the luxuriousness of

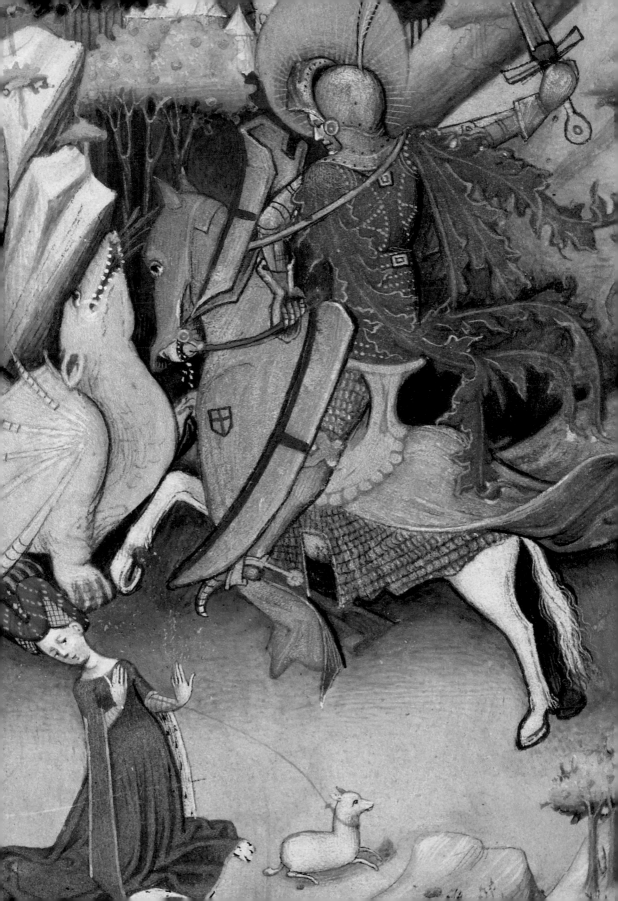

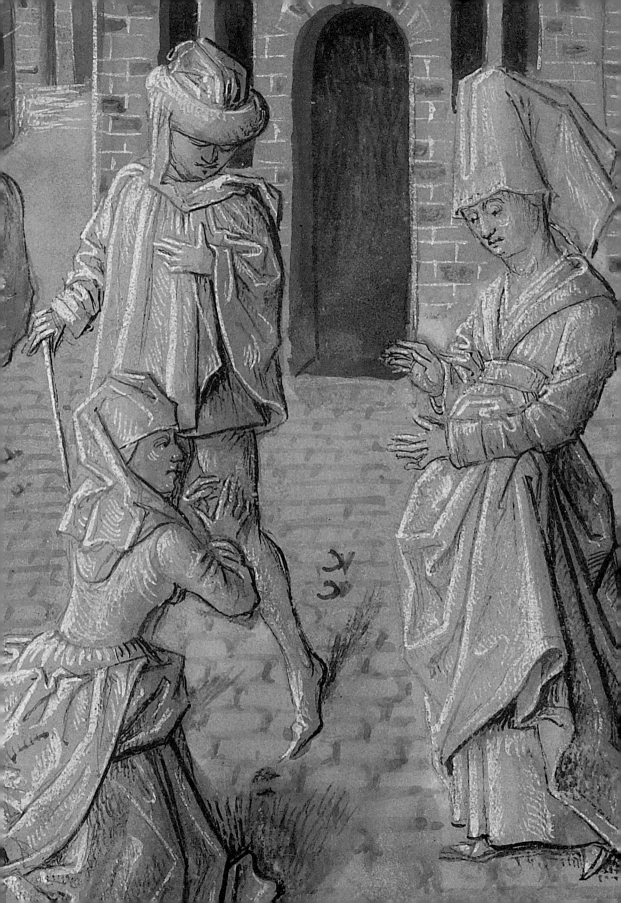

court costume was, not coincidentally, also a reflection of Flemish preeminence in the manufacture of luxury textiles and garments. By the second half of the fifteenth century, Philip's dominion, which had spread over two geographically separate regions since the late fourteenth century, included much of the Lowlands (as detailed above) and Burgundy along with neighboring territories in east-central France. As a political and military force it rivaled even France, the nation ruled by his Valois cousin, Charles VII (r. 1422–61). The Burgundian state had carved out its own place on the European stage.

While, as noted, the patronage of manuscript illumination had played an important role in Valois households since the time of Charles V of France, Philip the Good became a significant patron of manuscript illumination relatively late in his career, during the 1440s, though by that point he had already accumulated a substantial library through inheritance and gift. The sixty manuscripts that he commissioned include some of the most beautiful and extravagant books produced in Flanders up to that time. One was the second of two copies made for him of *Les Miracles de Nostre Dame* (*The Miracles of Our Lady*), ca. 1460, which was illuminated by Philip's court artist Lieven van Lathem (act. 1454–93). Van Lathem, known today as one of the finest illuminators of his generation, was also trained as a painter, and it is likely that, in addition to this manuscript and a splendid book of hours he illuminated for the duke, he executed paintings and all kinds of ephemeral decorations used in court ceremony and pageants. In 1468, Charles the Bold, Philip's son, paid Van Lathem for his contribution to the decorations for a meeting in Bruges of a chapter of the Order of the Golden Fleece.

The Getty owns a splendid miniature (pp. 16 and 64) removed from the copy illuminated by Van Lathem (Paris, National Library of France), a text compiled by Jean Miélot expressly for the duke. Miélot was an author, editor, translator, scribe, and apparently sometimes an illuminator as well (though not in this instance), and this work assembles various legends concerning the role of the Virgin Mary as intercessor for the Christian faithful. It illustrates the tale of a noblewoman who discovers that her husband is unfaithful. At the right in the miniature she beseeches the Virgin to intercede, but Mary advises her that the husband's mistress is actually devout and regularly recites the *Ave Maria* before Marian images. Subsequently the two women encounter each other

in the street. The noblewoman reveals that the Virgin has rejected her complaint, but the mistress, kneeling before her, is so ashamed she decides to give up her lover. The illuminator brings the story vividly to life, not only capturing the contemporary fashions of the characters but also rendering in a superbly evocative manner a Flemish town with handsome new buildings and cobblestone streets like those found in prosperous Ghent, where Van Lathem himself resided. One has to wonder how such a story of marital infidelity would strike the volume's patron; Duke Philip was himself a serial philanderer who fathered many more illegitimate than legitimate children. Drolly, the artist shows the wayward husband cowering in the background behind the chapel.

When completed, this copy of *The Miracles of Our Lady* had seventy-three miniatures, indicating how very sumptuous such books could be and how demanding a patron the duke was. He consistently required his artists to produce illustrations, often scores of them, for new texts as well as texts that had hitherto never been illustrated. A significant group of these commissions were histories and chronicles that were politically motivated, aimed at establishing the legitimacy of his claims to a particular county or province but also revealing his larger dynastic ambitions. *History of Charles Martel* tells of the outstanding military leader, grandfather of Charlemagne, who ruled the Frankish kingdom from 714 to 741 (pp. 65–67, leaf 3). A number of the stories and illustrations feature Girart de Roussillon (ca. 800–877/879), the duke of Burgundy — a great hero of the Burgundians—and an opponent of Martel, according to the text. (In medieval lore Roussillon and Martel were treated as contemporaries, possibly the result of a confusion of Martel with Charles the Bald [823–877], who was an opponent of Roussillon.) Philip also commissioned a sumptuously illuminated romance based on the life of Roussillon (Vienna, Austrian National Library), along with a life of Alexander the Great and chronicles of the provinces of Hainaut and Brabant. Philip and his knights undoubtedly took pleasure in and inspiration from the military exploits, courage, and leadership of such ancient heroes as Martel, Roussillon, and Alexander.

After Philip's death, his widow, Isabel of Portugal (1397–1471), devoted her energies to the duke's successor, her son Charles the Bold, who inherited his father's vast territories in 1467 along with his ambitions. Isabel commissioned for her son's benefit a

new life of Alexander the Great from Vasco da Lucena (1435–1512), a Portuguese member of the ducal household who dedicated his text to Charles. The text is based on the biography compiled by the ancient Roman writer Quintus Curtius Rufus in the first century A.D. The dedication page (p. 72) shows Vasco presenting his work to Charles, who is surrounded by courtiers and knights. The illustration offers an indication of Burgundian court splendor, especially in the extravagant, fashionable costumes of all parties, from the tall, plumed bowler-type hats to the long robes, the evidence of abundant gold thread in the fabrics, the tightly cinched waists, and the men's hose. A dedication image such as this commemorates the completion of the text and its presentation to an august patron. The dedication image appeared in many illuminated copies of the text, and hence does not imply that this is the copy actually given to the duke. While the Getty's is not the actual volume made for Charles (the latter is in the National Library of France), it is one of the most beautiful among surviving copies. The other miniatures in the book, though drawn from Alexander's life, also show settings reflecting contemporary Flemish architecture and court fashions; the tall bowler-type hats recur, for example (p. 73). These features made the narratives more accessible to their viewers, but they also underscored Charles's own strong identification with the conqueror Alexander, one of the great military leaders in history and the model for many a medieval ruler.

The *Chronique de Hainaut* (*Chronicles of Hainaut*) (Brussels, Royal Library of Belgium), one of the local histories commissioned by Philip the Good, was illuminated in part by an extremely successful Bruges illuminator named Willem Vrelant (act. 1449–81), originally from Utrecht. Despite the fundamentally conservative character of his art, Vrelant not only enjoyed the favor of the two dukes, father and son, but also produced luxury books for many prominent courtiers and bibliophiles, including Anthony of Burgundy (1421–1504), Louis de Gruuthuse (1422–1492), Charles de Croÿ, and others. Further, his career epitomizes Bruges's role as a European crossroads and especially a center for export. The Getty owns a lavish book of hours from the early 1460s (known today as the Arenberg Hours) with nearly ninety miniatures. Vrelant illuminated it for a noble English patron, who is shown with his spouse adoring the Eucharist set in an elaborate monstrance on the altar of a chapel (p. 69). England had

long enjoyed close political and economic ties with Flanders as an important source of wool for textile manufacture. Charles the Bold married an English princess, Margaret of York (1446–1503), whose brother, King Edward IV, would spend time in exile in Bruges. The Burgundian dukes exploited these ties to their advantage in dealing with their cousins and rivals at the French court. Because of this close relationship, the English had a strong diplomatic and mercantile presence in Bruges throughout the fifteenth century, including, quite possibly, the patron of this manuscript.

A more sophisticated and innovative artist than Vrelant was the aforementioned Lieven van Lathem. Over his long career, Van Lathem was responsible for a wide range of artistic production under the patronage first of Philip the Good and later of Charles and the Habsburg Archduke Maximilian I (1459–1519), the widower of and successor to Charles's daughter, Mary (1457–1482). Shortly after Charles's marriage to Margaret of York in 1468, Van Lathem created for the duke a small—less than five inches tall—but sumptuous prayer book (pp. 74–78), a volume that Charles could conveniently carry on his person as he traveled among his administrative centers and even onto the battlefield. Despite their tiny dimensions, the book's illuminations open up a spacious world of light, humanity, and even fantasy. The miniature of Saint Michael shows the archangel battling evil demons as he hovers over a broad river that seems to wend its way to infinity (p. 76). The book contains some of the most sophisticated landscape settings painted up to this time. Van Lathem had settled by 1462 in Antwerp, where he was the city's finest painter. Significantly, Joachim Patinir (ca. 1480/85–1524), the painter who established landscape painting as a specialty genre, also worked in Antwerp for much of his career. His influential ideas about panoramic landscapes drew heavily from Van Lathem's illuminations.

The prayer book of Charles the Bold is also distinguished by the inventiveness and vitality of its border decorations; they overflow with griffins, dragons, birds, and simian creatures (pp. 74–78). Further, the artist experimented with a relatively new feature that would soon become a standard characteristic of Flemish manuscript illumination: borders painted on solid-colored grounds, such as the one accompanying the miniature of *The Temptation of Saint Anthony* (p. 77). The lively border with a centaur and a soldier battling griffins is depicted in delicate grisaille amid swirling acanthus—

the combination of figures and large-scale vegetation recalls the borders of the Master of Guillebert de Mets (pp. 54–58)—and the gold background gives them a powerful presence on the page. The Vienna Master of Mary of Burgundy (act. ca. 1470–80), the most important illuminator of the generation after Van Lathem, contributed a haunting miniature of *The Deposition*, his earliest known work (p. 78). The book is also noteworthy for elegant and extravagant calligraphy, the work of Nicolas Spierinc (act. 1455–99), the finest Burgundian scribe and a favorite of Charles the Bold (p. 76).

 The money lavished on the production of luxurious illuminated manuscripts by Philip the Good and by his loyal courtiers had an extraordinary impact on the book trade, attracting the finest artists, encouraging innovation, and dramatically raising the quality of book production overall. Charles the Bold continued this trend, first by seeing that books begun for his father were completed, then commissioning further works, such as the splendid prayer book just discussed, and also encouraging wider patronage at his own court, including through the office of his consort, Margaret of York, the duchess of Burgundy. She was arguably the most interesting and aesthetically discerning bibliophile during Charles's reign. Among the many books she commissioned, the most beautiful and original is *Les visions du chevalier Tondal* (*The Visions of Tondal*, pp. 81–84), a French translation of an extremely popular Latin account of a young knight's vision of a journey through hell to discover the rewards of Christian repentance. The book was illuminated by Simon Marmion (ca. 1420–1489), one of the epoch's great illuminators and also a successful painter in oil on panel. He had established his reputation already in the 1450s with the illumination of a spectacular *Grandes Chroniques de France* for Philip the Good (St. Petersburg, The National Library of Russia). David Aubert, previously a scribe of Philip, wrote out the handsome Burgundian bâtarde script of Margaret's *Tondal* manuscript.

 The Visions of Tondal was originally written in Latin in Regensburg by an Irish monk called Marcus in about 1149, more than a hundred years before Dante wrote his *Divine Comedy*, a similar story of the journey of a human soul that is better remembered today. In Marcus's tale, a wealthy knight named Tondal—handsome, brave, and proud— visits a friend to collect a debt, but the friend cannot pay. Tondal, angered by the friend's insolvency, is nevertheless invited to dinner in an attempt to mollify him. An irreligious

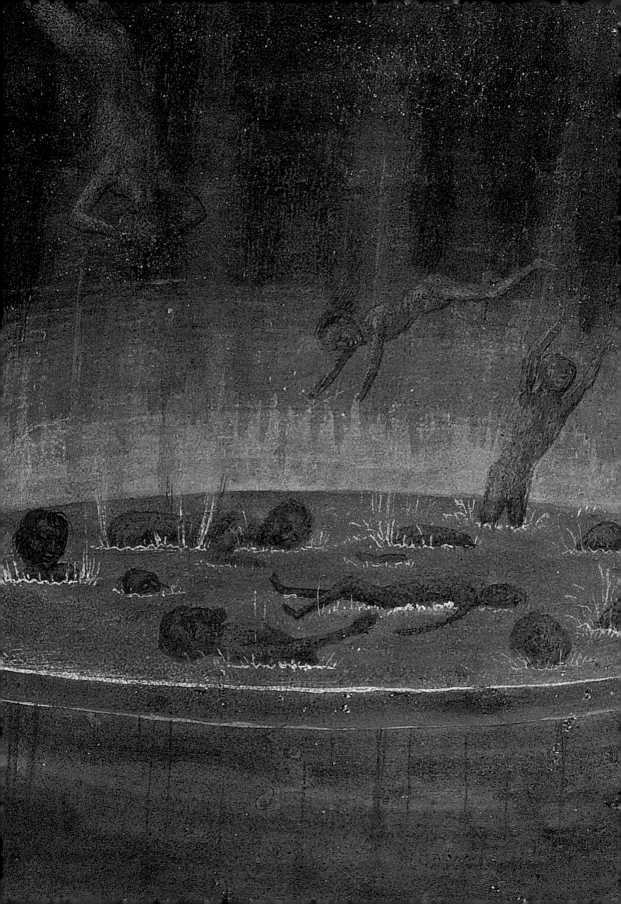

man, the agitated Tondal has a seizure at dinner (p. 81) and falls into a coma. His soul then departs his body to embark on a journey in which he will learn about the wages of diverse sins and the punishments suffered by the damned. The soul, accompanied by an angel, visits a deep valley covered by an iron lid upon which the souls of murderers are fried (pp. 22 and 82). Marmion conveys the intense heat of the fire both through the glow of its red-orange color and the steam that wafts from the surface. After encountering many other torments (e.g., p. 83), he is privileged to witness the eternal reward given to those who have hope for redemption in the eyes of God, such as the faithfully married (p. 84). Marmion fashions this blissful zone with a completely different palette, using white, gold, silver, and a few softer, prettier hues. Spiritual and devotional texts constituted an important component of Margaret's library. The volume that contained *The Visions of Tondal* also contained a treatise about purgatory, *La vision de l'âme de Guy de Thurno* (*The Vision of the Soul of Guy de Thurno*) (p. 85), illuminated with a dramatic frontispiece by Marmion and an illustrated life of Saint Catherine (France, private collection).

Margaret's bibliophily and her presence in the Burgundian Netherlands may have encouraged her brother Edward IV to start collecting Flemish illuminated manuscripts. Probably following not just her example but the model of the splendor of the Burgundian court, Edward purchased from the Burgundian Netherlands both ambitious tapestries and more than twenty illuminated manuscripts; most of the latter were historical texts, covering subjects both ancient and recent. Among the books were naturally those dealing with the history of England, including the monumental *Chroniques* (*Chronicles*) written by Jean Froissart (1337–ca. 1410). This book focuses especially on the period from around 1322 to 1410, in particular the conflict between England and France then in progress and known today as the Hundred Years War (still unresolved at Froissart's death). The Getty's copy (pp. 90–94), containing book three (out of four), probably belongs among the copies of Froissart that Edward IV acquired. It is the most extensively illustrated surviving volume of the *Chronicles*, with sixty-four colorful miniatures that describe intrigue, alliances, diplomacy, and military exploits across the continent in the brief period 1385 to 1389. The anonymous illuminator recounts, for example, the ambiguous story of the death of the king of Navarre, which

occurred when his servant, endeavoring to warm his bed in a conventional way—
by blowing warmed air through a tube—managed to ignite the entire bed (p. 93).
Was it an accident or an assassination? The small library of beautiful books acquired
by Edward IV, mostly in Bruges, has historical significance beyond the books'
sumptuousness and beauty. They formed part of the foundations of the English royal
library and eventually the modern British Library, just as the Burgundian ducal
library, with the holdings of Philip the Good at its core, provided a foundation for the
modern Royal Library of Belgium.

Texts in the French vernacular, such as *The Visions of Tondal* and the Froissart
Chronicles, enjoyed tremendous popularity at court. While Froissart wrote in the
vernacular, the popular *Tondal* may have been especially translated for the duchess, just
as other translations had been made for earlier Valois rulers. *Faits et dits mémorables
des romains* (*The Memorable Deeds and Sayings of the Romans*) is a compilation of stories
about ancient customs and heroes composed in Latin in the first century A.D. by
Valerius Maximus. King Charles V initially ordered this translation into French. The
Getty owns a miniature that belonged to a copy illuminated for Jan Crabbe, abbot
of the Cistercian Abbey of Ter Duinen not far from Bruges (pp. 25 and 87). Crabbe was
a bibliophile and an advisor to Charles the Bold. The miniature shows the author
instructing the Roman emperor Tiberius (to whom Valerius dedicated his original Latin
text) on the value of temperance. But the witty illuminator called the Master of the
Dresden Prayer Book (act. ca. 1460–ca. 1520) injects some irony into the narrative. The
noble, pious figures seated at the back of the spacious dining room embody temperance,
behaving in a decorous, even staid fashion. In the foreground, by contrast, peasants get
happily drunk, fall on the ground, and flirt with the women, implying that intemperate
behavior could be the more appealing path. In Flemish art over the next two centuries,
drunkenness and other foibles of the non-aristocratic classes would become beloved
subjects of Netherlandish painters such as Adrian Brouwer (1605/6–1638) and Jan Steen
(1626–1679).

Until painters like Jan van Eyck brought a new luminosity and realism to
painted images in oil on panel (and more paintings began to survive), manuscript
illumination often provided the most refined, naturalistic, and subtle form of painting

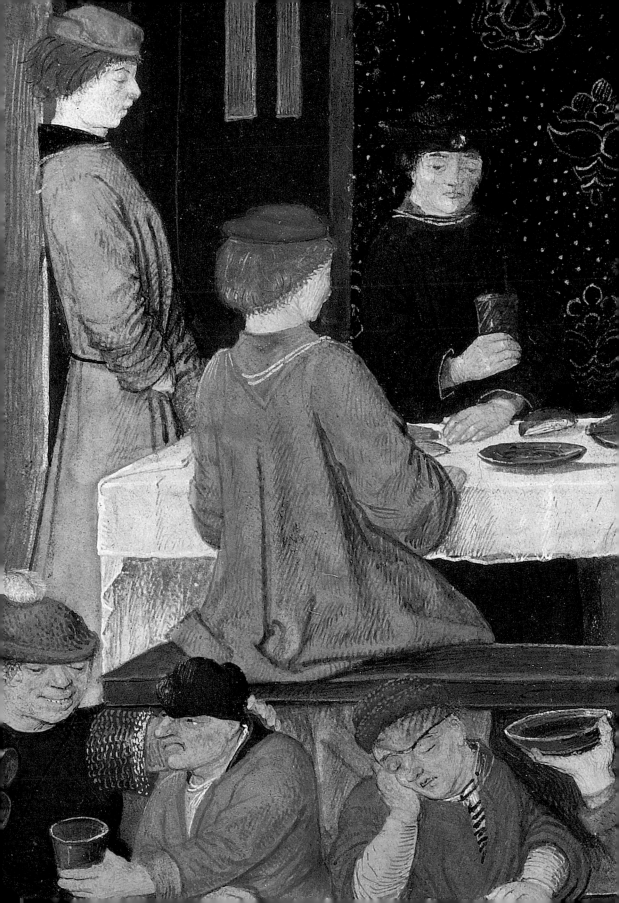

known to northern Europe. But the triumph of oil painting also provided a wonderful impetus to illuminators to achieve ever richer effects, such as the remarkable depictions of fire emerging from the darkness of hell in Marmion's *Visions of Tondal*. Given that Marmion himself was trained in the oil technique—many artists of the time practiced more than one artistic métier—it is not surprising to find its influence in his illuminations, though these were always executed in the water-soluble medium of tempera. Indeed in the decade of the 1470s, the bond between the arts of painting in oil and illumination in tempera became increasingly close, as exemplified by anonymous illuminators such as the Vienna Master of Mary of Burgundy (p. 78),and the Master of the Houghton Miniatures (pp. 88–89), who were likely both active in Ghent. The nocturnal *Annunciation to the Shepherds* by the latter illustrates the ongoing centrality to these artists of rendering subtle light effects, including the subdued luminosity of this scene. Only the golden aureole that envelops the angel above the shepherds and the golden light in the stable's windows on the distant hilltop of Bethlehem provide sources of light. The landscape is nonetheless complex and richly detailed, a sequence of rolling hills with shadowy dales, including at the right a castle below the shepherds and a vista that opens beyond. The nocturnal light, beautifully proportioned landscape setting, and the shepherds' rough features and humble postures imbue the scene with poetry and immediacy.

This sophisticated naturalism began to manifest itself in still other ways starting in the 1470s, and these approaches endured for several generations. The most notable is the transformation of the decorated border areas into an arena filled with flowers and other flora and fauna that are not only painted with great attention to detail, such as the accurate color and textures of the individual blooms, but also three-dimensionally; the flowers, leaves, and their vines often cast their own shadows on the page (pp. 95 and 98). This practice greatly enriched the luminosity of the page as a whole, and the best examples gave the natural motifs an immediacy that could fool the eye. One is tempted to try to gather up the flowers, which sometimes seem as though casually strewn around the border.

Other forms of illusionism developed in turn. In one of the most original Flemish manuscripts of the sixteenth century, the Spinola Hours, the artist attempted to

fool the eye in diverse ways, sometimes with the type of strewn borders just mentioned (p. 110), but in other instances with the text on the page treated as if written on a scrap of parchment that in turn is pinned to the miniature itself (pp. 102–103). It is not real but an illusion—and a virtuoso display of the artist's mastery of light, texture, and form. In two other examples, showing a deathbed scene and a funeral mass, the illuminator, called the Master of James IV of Scotland (Gerard Horenbout?), reserves the space above the text for an interior scene, while the border that surrounds it shows the exterior of the same building (pp. 108–109). In *The Funeral Mass*, moreover, the miniature shows the choir of the church while the image below the text shows the crypt (or basement level) where the deceased will eventually be interred. The artist's resourcefulness transforms the seemingly awkward compartmentalization of the page between text, miniature, and border—a convention of prayer books at this time—into an unusual opportunity: he manages to show in a convincing way both the interior and the exterior, illustrating successive events in a narrative sequence. While friends attend the dying man inside the splendid home, another drama plays out in the garden below, where Death in the guise of a spear-wielding skeleton attacks young noblemen (p. 108). In the early sixteenth century, when life expectancy was short, devotional art often included reminders of how death could come when least expected.

The Spinola Hours was created around 1510–20. By this time the Burgundian rulers of the Netherlands had been supplanted by their heirs, the Habsburgs, as a result of the marriage of Mary of Burgundy, daughter of Charles the Bold, to Maximilian I, the son of the Habsburg emperor. Indeed some scholars believe that the book may have been made for their daughter, Margaret of Austria (1480–1530), regent of the Netherlands under her nephew, Emperor Charles V (r. 1519–56). She was one of the great bibliophiles of her generation. The Master of James IV of Scotland, the book's main and most innovative illuminator, is often identified as the Ghent painter-illuminator Gerard Horenbout (before 1465–ca. 1541), whom Margaret appointed her court artist in 1515.

The Spinola Hours is a work of extraordinary ambition even for a private prayer book. It contains more than eighty miniatures and sixty-three historiated borders along with some form of decorated border on both sides of every one of its three hundred leaves. Many of the borders are of the illusionistic, strewn-flower type that

came into vogue during the 1470s, showing the enduring popularity of this border style. Moreover, many of the miniatures are also paired in the two-page openings in different ways, to show the fulfillment of Old Testament narrative in the Gospel stories and church doctrine (pp. 102–103), to parallel the narratives of Christ's childhood with his Passion and death (pp. 104–105), or to sustain a narrative sequence (pp. 108–109). Also illustrative of the taste of the most discerning patrons at the beginning of the sixteenth century, this exceptional campaign of illumination was carried out not by one artist and his workshop but by a team of the finest artists working at that moment, including the Master of the Dresden Prayer Book (pp. 104–105), the Master of the Lübeck Bible (p. 110), the Master of the Prayer Books of ca. 1500, and the Master of the First Prayer Book of Maximilian. An extravagant manuscript like this one became a kind of independent gallery of paintings that featured the most fashionable illuminators. As they had since the thirteenth century, illuminated devotional books remained exemplars of the taste and wealth of their patrons, but now on an even more lavish scale.

The Master of James IV of Scotland was the finest Flemish illuminator of his generation. He was succeeded in this distinction by Simon Bening (1483/84–1561), who produced manuscript illumination that closely hewed to the naturalism and the rich pictorial qualities that preceded him. Bening continued to enjoy the patronage of the Habsburg ruling family and its courtiers, down to Emperor Charles V (r. 1519–56) and his consort, Isabella of Portugal. Charles's grandfather, Maximilian I, had married his two children by Mary of Burgundy to heirs of the Spanish monarchy so that the next generation ruled not only the Netherlands but also Spain, facilitating the further rapid expansion of the European market for Flemish manuscript illumination of this period and considerably broadening its circle of noble patrons. The Germans and Portuguese were increasingly important patrons as well. One such individual was Cardinal Albrecht of Brandenburg (1490–1545), archbishop and elector of Mainz, who was an avid collector of art and relics and a patron of Albrecht Dürer, Lucas Cranach, Matthias Grünewald, and the Nuremberg sculptor Peter Vischer. He sold indulgences to finance the costly and splendidly crafted religious objects that he coveted. It was this clerical sale of indulgences that provoked Martin Luther to write his celebrated Ninety-

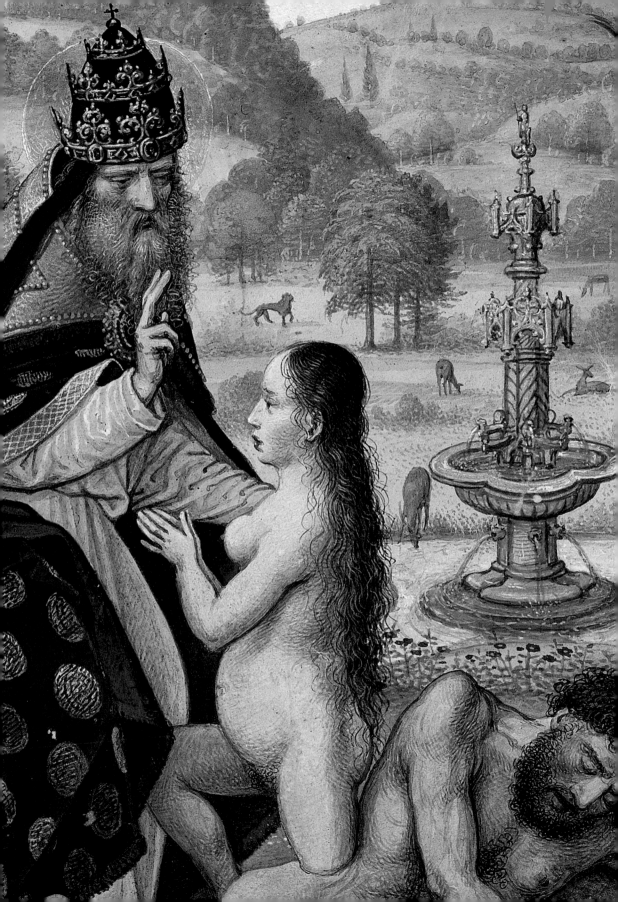

five Theses—originally addressed to Cardinal Albrecht himself—and ultimately led to Luther's excommunication and the Protestant Reformation. This attack did not, however, put a stop to Brandenburg's extravagant artistic patronage.

An indication of the continuing success of manuscript illumination as late as the 1520s is the fact that the printing press had been introduced to the world about seventy years before Brandenburg commissioned his remarkable prayer book from Bening (p. 29 and 111–119). Indeed, like some other bibliophiles of his day, Brandenburg favored luxurious handmade books over printed ones. The text of this prayer book was actually transcribed from a printed book, an illustrated collection of prayers relating to the Passion of Christ that was printed in Augsburg in 1521. Bening took a handwritten copy of the printed text and provided it with forty-two entirely new, hand-painted illustrations, forty-one of which survive in the Getty's manuscript.

Here the verisimilitude of Bening's art combines with a great story told in many scenes, resulting in an uncommonly vivid and immediate experience. The artist exploits the drama inherent in turning the page so that each new image reveals another confrontation between Christ and his persecutors (pp. 114–116). Bening brings Christ to life through the accumulation of narrative incident and subtle characterization. The artist underscores Christ's human side and vulnerability, encouraging the reader to identify with his suffering (for an earlier example of this practice, see pp. 48–49). He also follows the conventions of recent Flemish illumination in heightening the drama via a nocturnal setting; many scenes are illuminated only by flickering torchlight. The scene of Joseph of Arimathea asking Pilate for the body of the dead Christ (p. 119), displaying a handsome array of stone buildings in the Netherlandish style, shows a remarkably consistent aesthetic of naturalism steeped in the artist's own environment. This aesthetic can be traced back to the time of Philip the Good; it is evident in such diverse illuminations as the Eyckian *Christ Blessing* (p. 50) and the grisaille miniature from the duke's *Miracles of Our Lady* (p. 64).

Bening created illuminated manuscripts over a period of more than fifty years, many of which are considered among the best works of his time. A miniature (p. 120) from a book of hours made for a Spanish courtier of Charles V shows a later phase of his style when his treatment of settings become more atmospheric, the light more diffuse,

and the brushwork finer. However, well before Bening died, the number of younger artists prepared to undertake careers as illuminators had greatly diminished. Indeed it is probably indicative that the children of both Horenbout and Bening found their separate ways to England to take up careers as artists, several of them apparently switching their focus from the illumination of devotional books and chronicles to the painting of miniature portraits. They were undoubtedly following the demands of the market. For all intents and purposes the great tradition of manuscript illumination—and certainly the possibility of enjoying a career primarily as a manuscript illuminator—had come to an end in the Netherlands as it was also slowly doing in France, Italy, and Germany.

Nevertheless there is more. In 1561 Bening died. The same year, the Holy Roman Emperor Ferdinand I (r. 1556–64), the younger brother of Charles V, commissioned his court secretary, Georg Bocskay (d. 1575), to write out a model book of calligraphy. A calligraphic model book is just what the name implies, a collection of samples of writing in myriad different styles: Gothic (p. 123), humanist (p. 126), italic, cursive (p. 125), and so on, including mirror writing (p. 124). The model book of calligraphy arose, ironically enough, out of the ashes of the illuminated manuscript. The rapid growth and popularity of printed books increased literacy, and with it came a new demand among the literate to learn how to write. This in turn led to a rise in the use of calligraphy as a means of self-expression. Calligraphic model books were sufficiently popular that they were widely disseminated, largely in printed copies.

For most of his life Ferdinand I ruled the Austrian domains of the Habsburgs, including Bohemia and Hungary. He, too, was a descendant of Philip the Good. The model book Ferdinand commissioned eventually passed to his grandson, Rudolf II (r. 1576–1612). During the 1590s Rudolf, himself a voracious art collector and a patron of the sciences, engaged the services of the Antwerp-born painter Joris Hoefnagel (1542–1600/01) to illuminate the individual writing samples. Hoefnagel was primarily a painter and draftsman, also admired today for his elegant drawings of landscapes and plants, the latter usually in watercolor. This background is strongly reflected in the exquisitely composed imagery of the Getty's *Model Book of Calligraphy* (pp. 32 and 122–127). His work took him away from Antwerp for much of his career, to Venice, London,

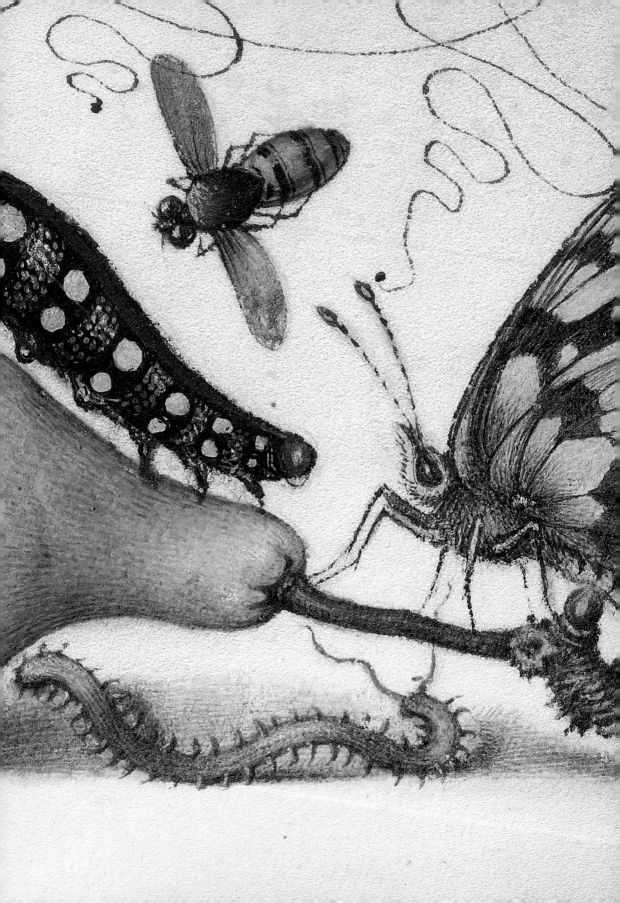

Munich, Frankfurt am Main, and ultimately Vienna, where he likely executed all or most of his illuminations for the model book. He furnished the book with a world of natural specimens as varied as the script types they accompany, each meticulously rendered with a verisimilitude that takes the illusionistic strewn borders of the late fifteenth-century tradition (see p. 110) to a new level. Not only do the objects cast their own shadows but they are no longer compartmentalized. Instead they fill up much of the lower part of each page, sometimes enveloping the text (p. 123) but always seamlessly united with it. The virtuosity of the illuminator perfectly complements that of the scribe, the display of virtuosity being central to the aesthetic of both.

Hoefnagel, in addition to illuminating Bocskay's splendidly written pages, added an entire section, twenty-two leaves of constructed alphabets of Roman uppercase letters (majuscules) and Gothic lowercase letters (minuscules, p. 127), an appropriate complement to what precedes it. He then illuminated them with a complex program that not only represents a variety of plant and animal forms but also a wider range of motifs, including grotesques, masks, architecture and architectural elements, and emblems that refer to Rudolf II and his authority as emperor. This section of the book was signed by Hoefnagel with his monogram and the date 1596.

Though he was not an illuminator by trade, Hoefnagel produced half a dozen illuminated manuscripts in his career, most for the Habsburg court, which are as lavish as the Getty's model book. So while he was not first and foremost a painter of manuscripts, he was the last of the great illuminators from the Netherlands. Indeed it is fitting that, from the middle of the fifteenth century until the end of the next, the great flowering of manuscript illumination in the Netherlands took its impetus primarily from the court that was first Burgundian and then, by marriage and direct descent, Habsburg, an impetus that had an extraordinary impact at court and beyond, making Netherlandish manuscript illumination a truly international phenomenon.

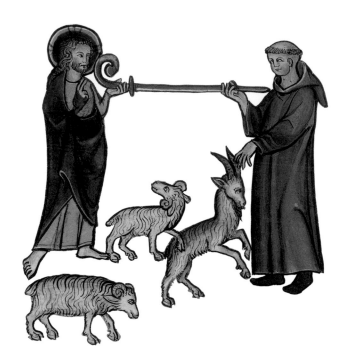

When the Getty Museum purchased the collection of Peter
and Irene Ludwig of Aachen, Germany, in 1983, Burgundian Netherlandish manu-
script illumination was already one of its strengths. Included in the Ludwig group were
the two extraordinary sixteenth-century manuscripts—the Prayer Book of Albrecht
of Brandenburg and the Spinola Hours—along with the Froissart *Chronicles*, the
leaves from *History of Charles Martel*, the bestiary, and the Arenberg Hours (pp. 68–69)
by Willem Vrelant. All had been purchased through H. P. Kraus, a dealer who had
wide-ranging sources and was tireless in his pursuit of great books. Kraus had acquired
the Brandenburg prayer book in 1956 from the great Geneva collector Martin Bodmer.
It has a distinguished provenance, having belonged to the noble family of Schönborn
at Pommersfelden and then the Vienna bibliophile Anselm Solomon von Rothschild
(1803–1874). (Coincidentally, the Froissart *Chronicles* once belonged to the French
branch of the Rothschild family.) Purchased by Peter Ludwig in 1960, the Brandenburg
prayer book belonged to the first campaign of important purchases he made from Kraus,
including major works that had appeared in the celebrated Dyson Perrins sales between
1958 and 1960. (The bestiary [pp. 43–47] and the book of hours possibly from
Brabant [pp. 60–63] were Dyson Perrins manuscripts.) In 1962, Kraus sold Ludwig the

Llangattock Hours, a book that had caused something of a sensation at the time of its discovery in the late 1950s due to the relationship of many of its miniatures to the art of Jan van Eyck. The Ludwigs put together a strong core of Netherlandish manuscripts fairly rapidly in the early 1960s, a heady period for collectors of manuscript illumination, while the Spinola Hours was acquired toward the end of their manuscript collecting years, in 1976. The book had been completely unknown until it was consigned to Sotheby's earlier that year. However, like the Llangattock Hours, this book also created great excitement and set a record price for an illuminated manuscript, $750,000; this may seem a paltry sum in the present art market, but it certainly was not then. Another of the important collections from which Kraus purchased books subsequently sold to the Ludwigs is that of the duke of Arenberg.

The Getty Museum has been fortunate that the supply of exceptional Flemish manuscripts, leaves, and cuttings continued to be strong on the market in the ensuing decades, especially fifteenth- and sixteenth-century material from the Burgundian Netherlands. It was also fortuitous, given that artists such as Simon Marmion and Lieven van Lathem were also painters and that the work of illuminators such as the Vienna Master of Mary of Burgundy and the Master of the Houghton Miniatures reflect so clearly the values of the oil painters of their day. It has proven to be far more difficult to build a significant collection of early Netherlandish oil paintings in the waning twentieth and early twenty-first century. Thus this portion of the manuscripts collection also represents for our visitors this important chapter in the history of European painting at the end of the Middle Ages and the dawn of the Renaissance.

Following the purchase of the Ludwig collection, Kraus, by then quite elderly, also sold the Museum the lavish hours by the Master of Guillebert de Mets that he had purchased three years before in the sale of the John Carter Brown Library of Providence, Rhode Island. As it turned out, some of the other major opportunities for acquisitions came from North American collections, notably *The Visions of Tondal* and *The Vision of the Soul of Guy de Thurno* from the collection of the great bibliophile Philip Hofer of Cambridge, Massachusetts, the Valerius Maximus cutting from the Randall collection in Montreal, and the Crohin-La Fontaine Hours (pp. 95–97), also by the Master of the Dresden Prayer Book, from the Robbins family collection in Berkeley, California.

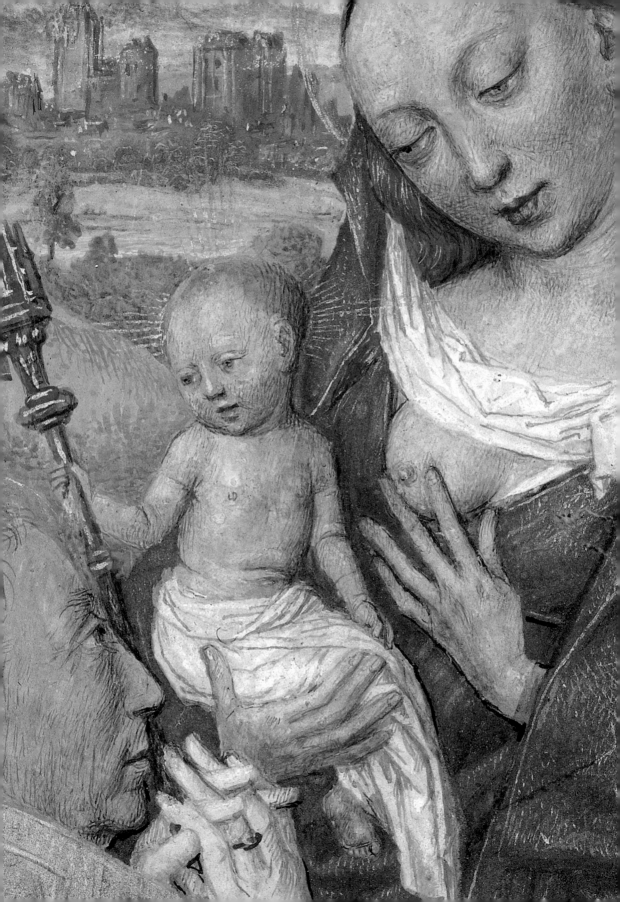

The latter had previously belonged to the distinguished American bibliophile Cortlandt F. Bishop. At the same time the Museum continued to buy internationally, including several noteworthy pieces from prominent collectors, such as the *Model Book of Calligraphy* from August Laube of Zurich; the Prayer Book of Charles the Bold from the heirs of Paul Durrieu, the eminent French manuscripts scholar who first discovered and published it; and the ravishing Marmion miniature, *Saint Bernard's Vision of the Virgin and Child*, from the Ganay family (pp. 36 and 86). A few items qualify with the Spinola Hours as recent discoveries, notably the Eyckian leaf from the Turin-Milan Hours, which was unknown and unrecorded prior to its appearance on the art market in 2000, and the miniature from Philip the Good's *Miracles of Our Lady*, which had belonged to a titled English family since the nineteenth century but only became publicly known in 2009. These acquisitions have enabled the Getty to form a superb collection of Netherlandish manuscript illumination that, while not large, is remarkably rich and varied, distinguished for its overall quality, and, above all, strongly representative of the great achievements of Burgundian Netherlandish manuscript illumination of the late fifteenth and sixteenth centuries.

Thomas Kren
Senior Curator of Manuscripts

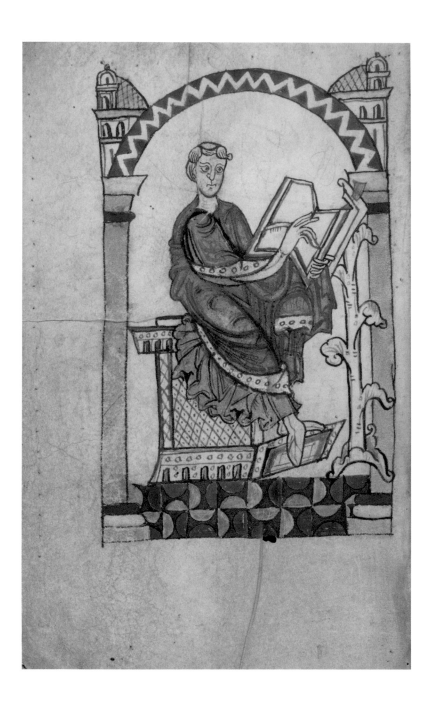

Eadmer of Canterbury Writing

Eadmer of Canterbury, *De vita et conversatione Anselmi Cantuariensis,* fol. 2v
Probably Tournai, Benedictine Abbey of Saint Martin (?), ca. 1140–50
Leaf: 17.8 × 10.8 cm (7 × 4¼ in.)
Ms. Ludwig XI 6; 83.MN.125

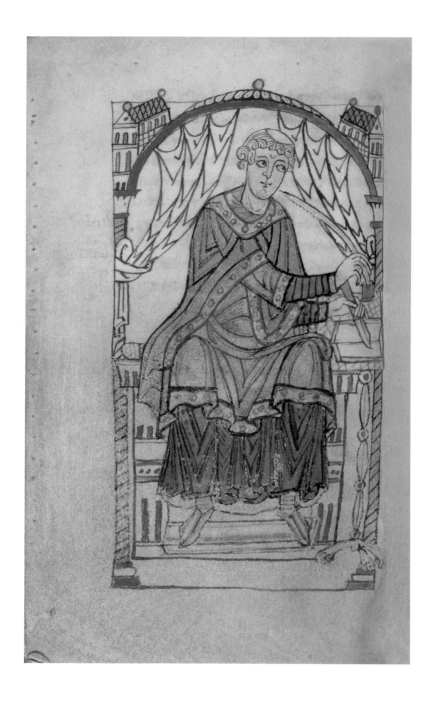

Eadmer of Canterbury Writing

Eadmer of Canterbury, *De vita et conversatione Anselmi Cantuariensis,* *fol. 44v*
Probably Tournai, Benedictine Abbey of Saint Martin (?), ca. 1140–50

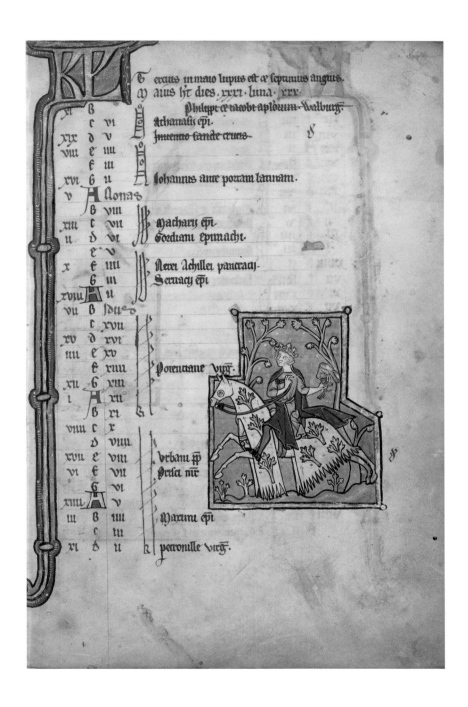

May: Calendar Page with a Man Hawking

Psalter, use of Ghent, fol. 5
Flanders (possibly Bruges),
mid-thirteenth century
Leaf: 23.5 × 16.5 cm (9¼ × 6½ in.)
Ms. 14; 85.MK.239

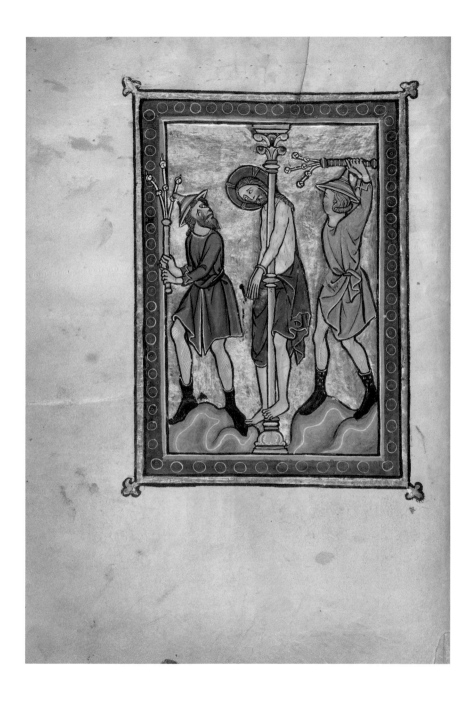

The Flagellation

Psalter, use of Ghent, fol. 12v
Flanders (possibly Bruges),
mid-thirteenth century

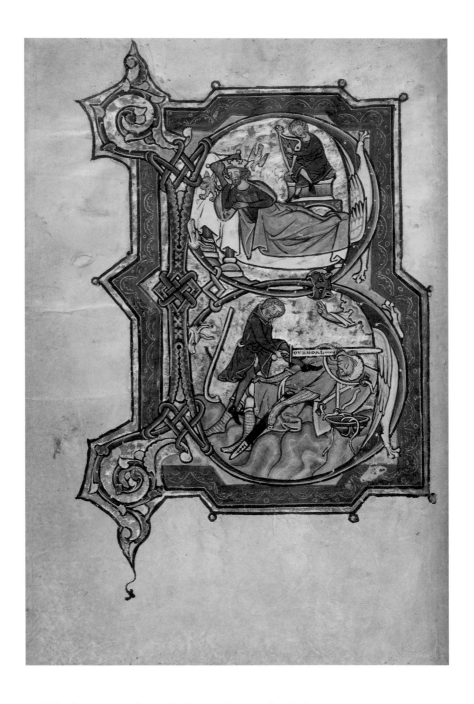

**Initial B (Beatus Page): David Playing the Harp for Saul;
David and Goliath**

Psalter, use of Ghent, fol. 16v
Flanders (possibly Bruges),
mid-thirteenth century

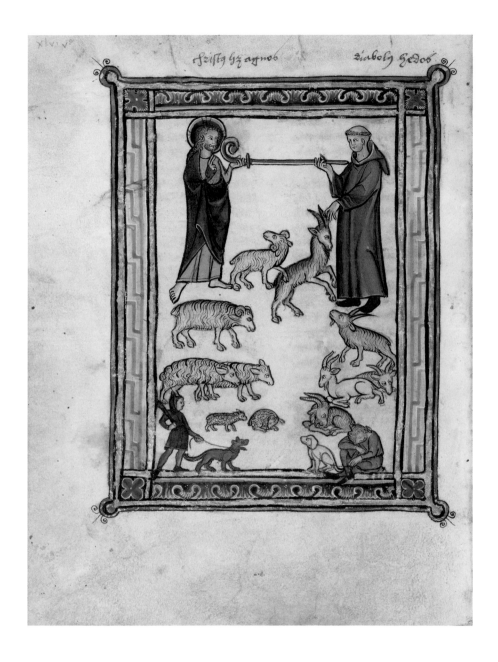

Christ and a Monk with Animals

Bestiary, fol. 46v
Flanders, ca. 1270
Leaf: 19.1 × 14.3 cm (7½ × 5⅝ in.)
Ms. Ludwig XV 3; 83.MR.173

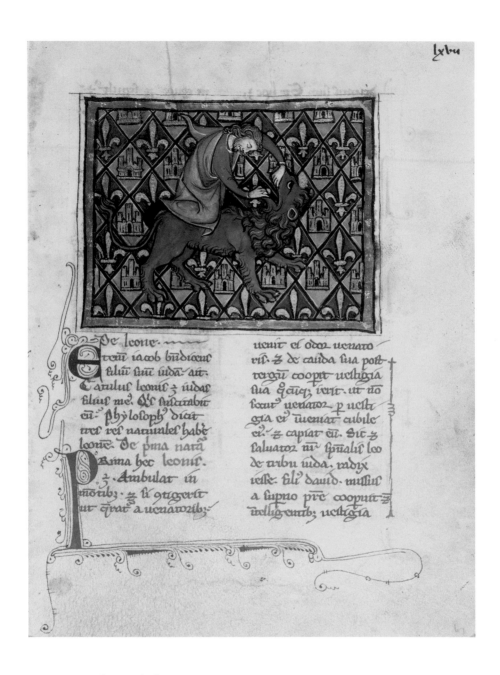

Samson Wrestling with the Lion

Bestiary, fol. 67
Flanders, ca. 1270

44

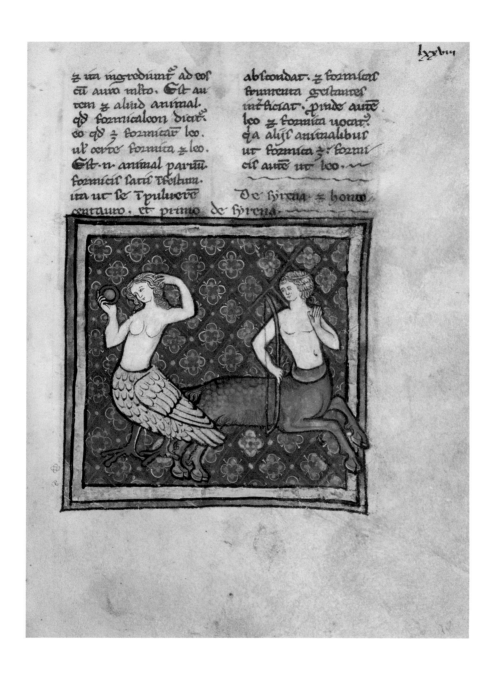

A Siren and a Centaur

Bestiary, fol. 78
Flanders, ca. 1270

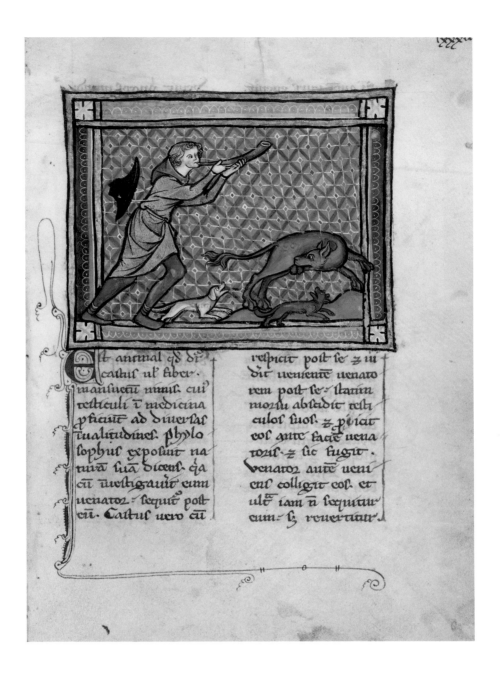

et animal qd di
catur ul liber.
manfuetu nimis cui
teftculi i medicina
pheuu ad diuerfaf
tualitudinef. phylo
fophuf expofuit na
turā fuā dicenf. qa
cū ueftigauit cum
uenatoz. fequit poft
eū. Caftuf uero cū

refpicit poft fe z ui
dit ueniente uenato
rem poft fe. ftarim
mozfu abfcidit teft
culof fuof. z piciat
eof ante facie uena
torif. z fic fugit.
Venatoz autē ueni
enf colligit eof. et
ult iam ū fequitur
eum. fz reuertitur.

A Hunter Pursuing a Beaver

Bestiary, fol. 83
Flanders, ca. 1270

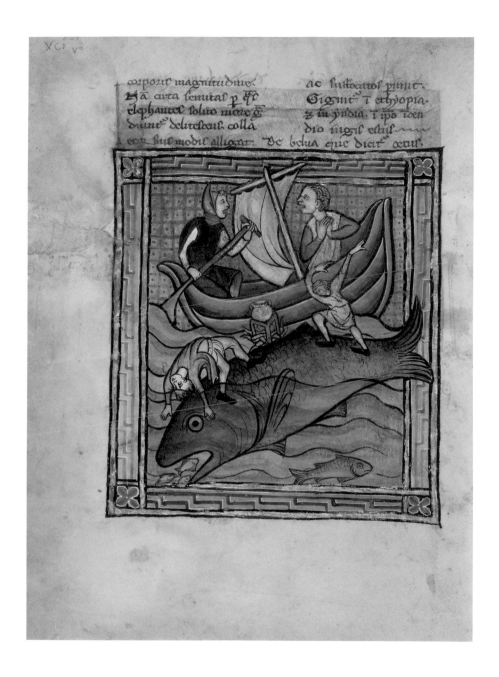

Two Fishermen on an Aspidochelone

Bestiary, fol. 89v
Flanders, ca. 1270

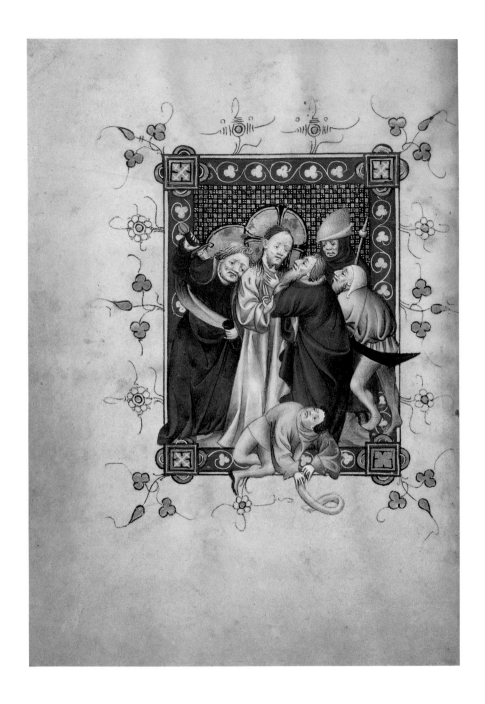

Masters of Dirc van Delf | The Betrayal of Christ

Book of hours, fol. 13v
Probably Utrecht, ca. 1405–10
Leaf: 16.5 × 11.7 cm (6½ × 4⅝ in.)
Ms. 40; 90.ML.139

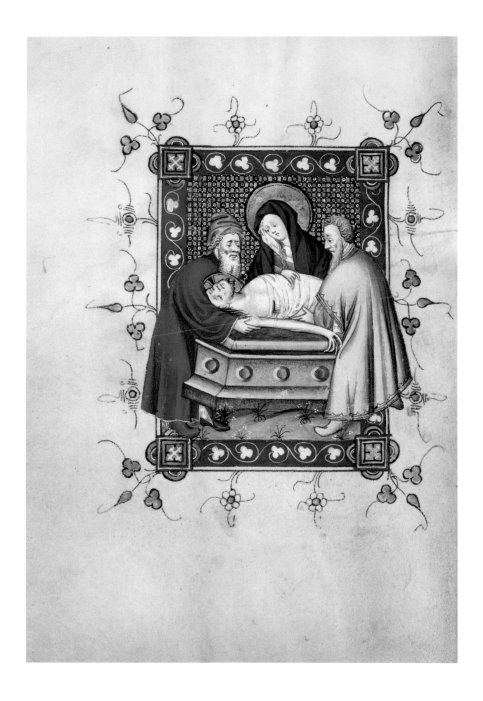

Masters of Dirc van Delf | The Entombment

Book of hours, fol. 79v
Probably Utrecht, ca. 1405–10

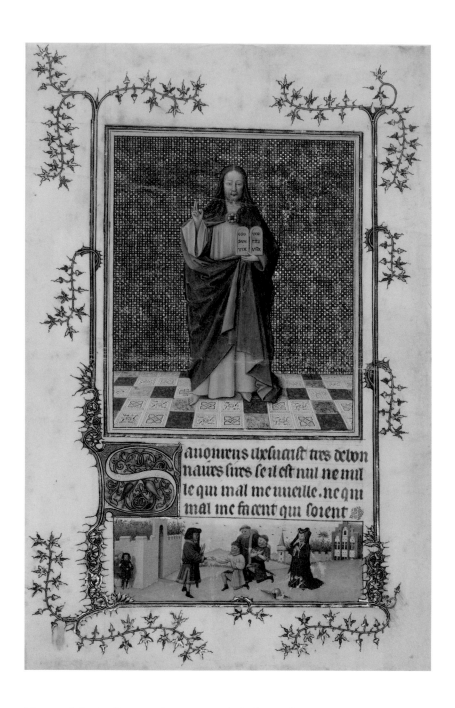

Master of the Berlin Crucifixion or Circle | Christ Blessing; Master of Jean Chevrot or Circle | Bas-de-page miniature

Leaf from the Turin-Milan Hours
(above) and detail (right)
Bruges, ca. 1440–45
Leaf: 27.2 × 17.6 cm
(10¹¹/₁₆ × 6¹⁵/₁₆ in.)
Ms. 67; 2000.33

50

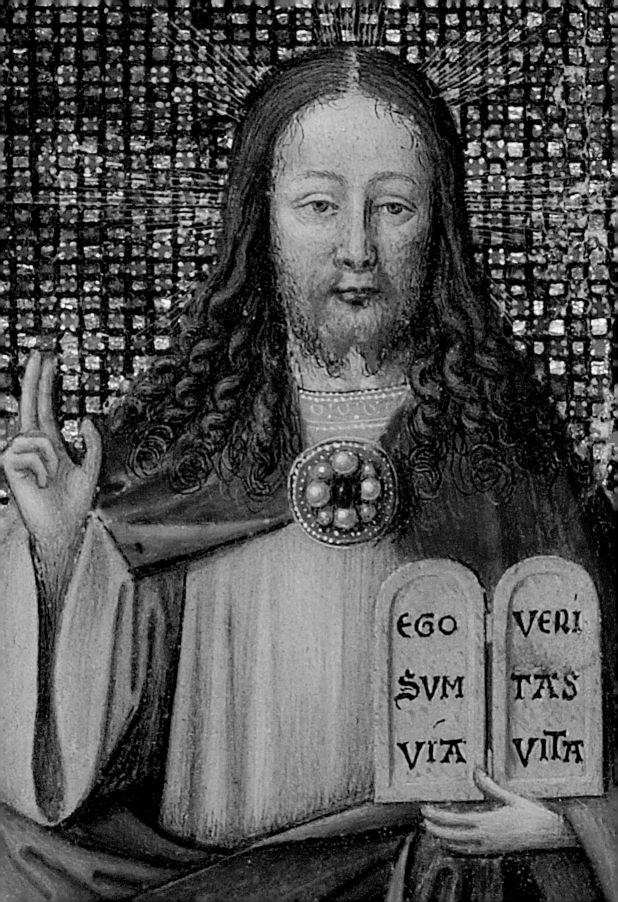

EGO VERI
SVM TAS
VIA VITA

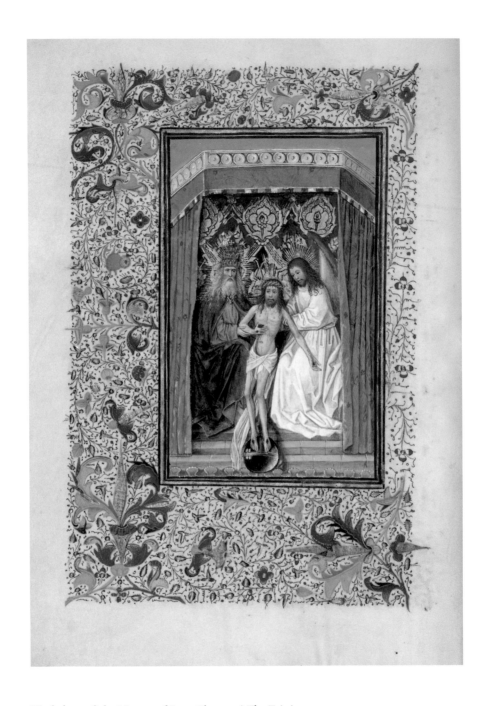

Workshop of the Master of Jean Chevrot | **The Trinity**

Llangattock Hours, use of Rome,
fol. 25v
Bruges and Ghent, 1450s
Leaf: 26.4 × 18.4 cm
(10³⁄₈ × 7¼ in.)
Ms. Ludwig IX 7; 83.ML.103

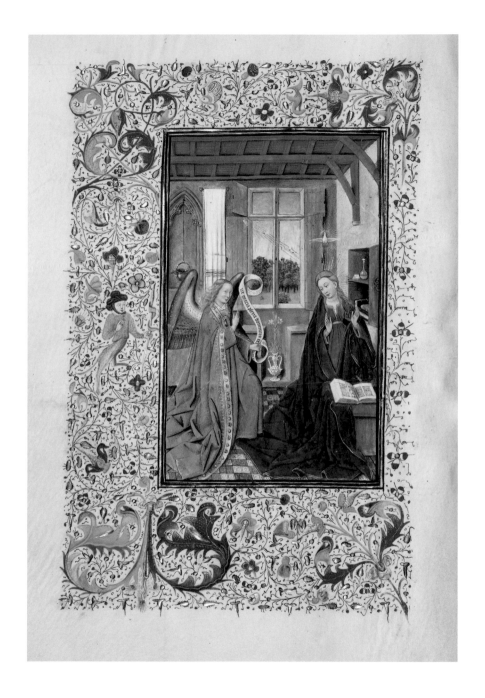

Willem Vrelant and the Master of the Llangattock Hours | The Annunciation

Llangattock Hours, use of Rome,
fol. 53v
Bruges and Ghent, 1450s

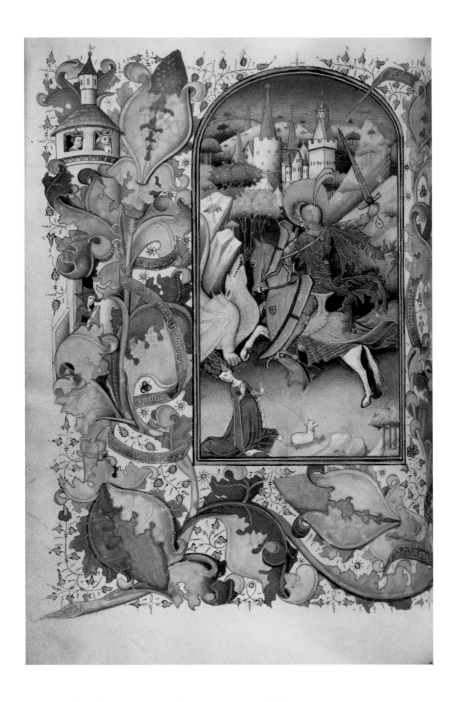

Master of Guillebert de Mets | Saint George and the Dragon

Book of hours, fol. 18v
Probably Ghent, ca. 1450–55
Leaf: 19.4 × 14 cm (7⅝ × 5½ in.)
Ms. 2; 84.ML.67

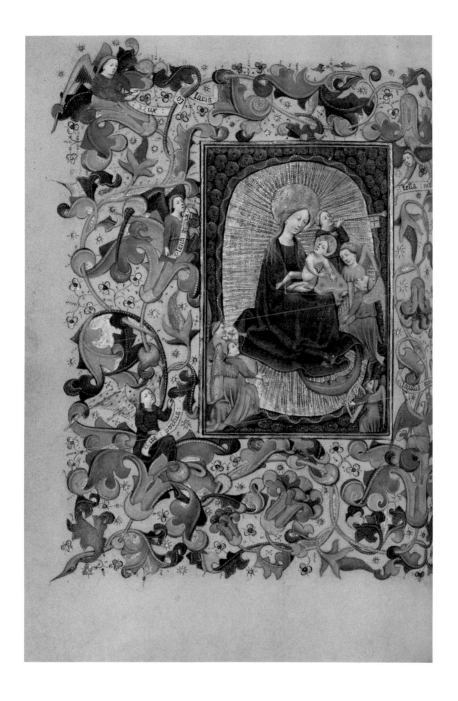

Master of Guillebert de Mets | The Virgin and Child with Angels

Book of hours, fol. 37v
Probably Ghent, ca. 1450–55

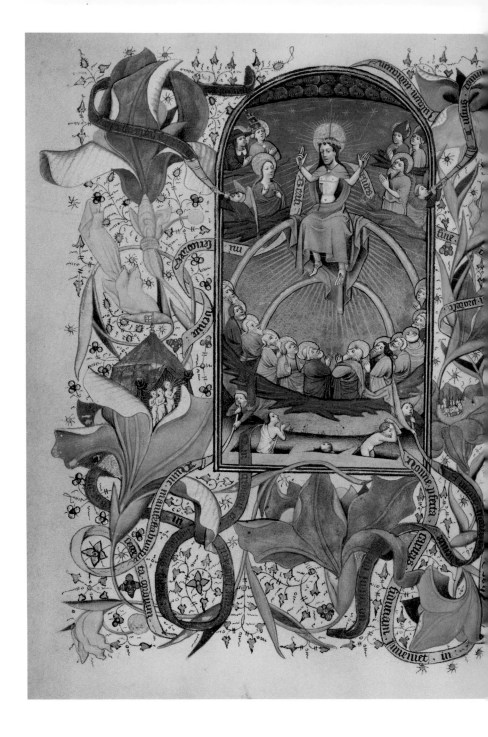

Master of Guillebert de Mets | **The Last Judgment** (left); **David in Prayer** (right)

Book of hours, fols. 127v–128
Probably Ghent, ca. 1450–55

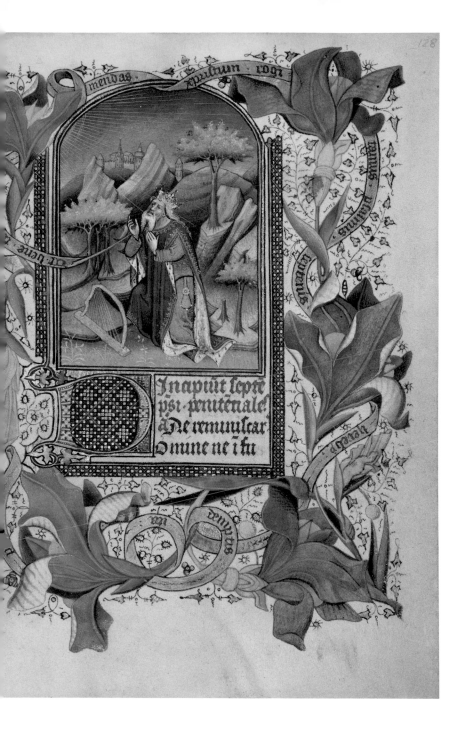

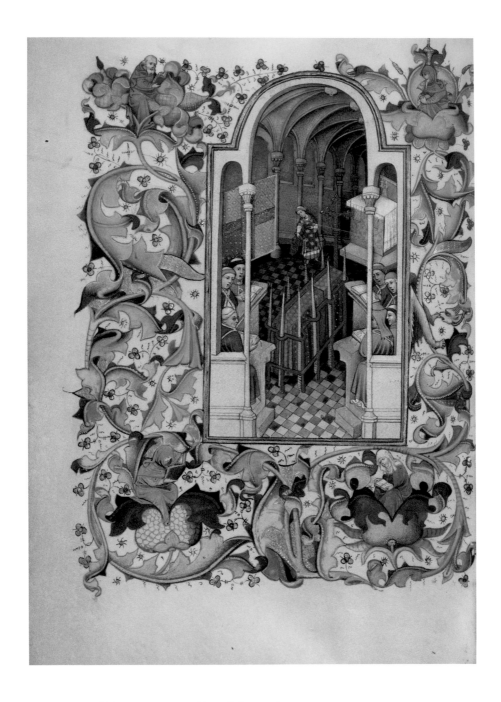

Master of Guillebert de Mets | Office of the Dead

Book of hours, fol. 175v
Probably Ghent, ca. 1450–55

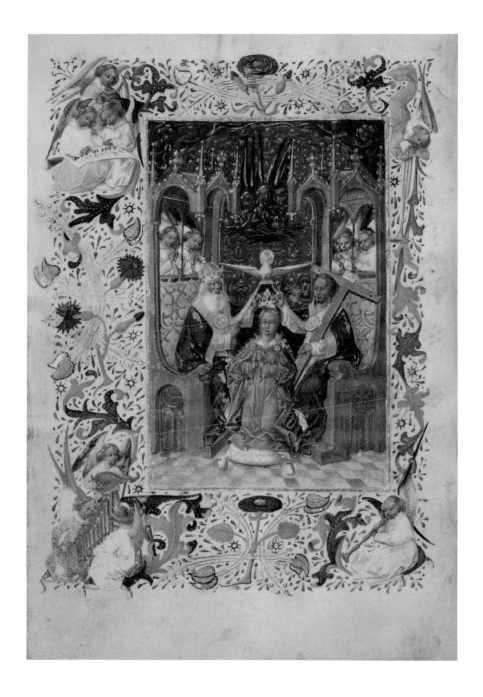

Master of Evert Zoudenbalch | The Coronation of the Virgin

Book of hours, use of Utrecht, fol. 15v
Utrecht, ca. 1460
Leaf: 16.4 × 11.7 cm (6⁷/₁₆ × 4⁵/₈ in.)
Ms. Ludwig IX 10; 83.ML.106

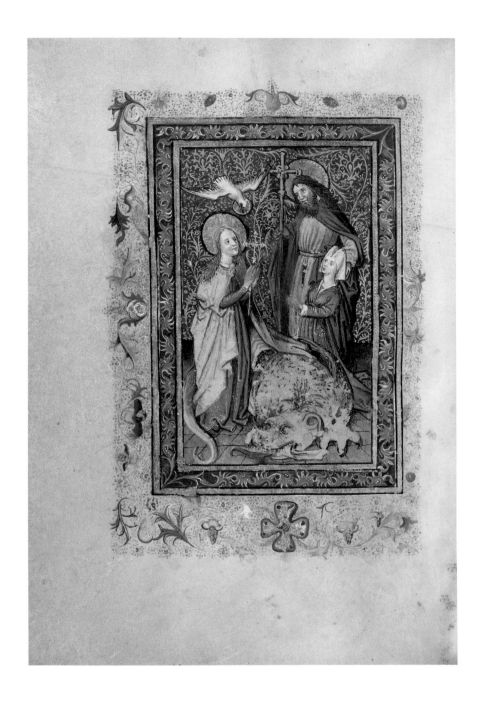

A Male Saint Presenting the Patron to Saint Margaret

Book of hours, use of Utrecht, fol. 13v
Possibly Brabant, after 1460
Leaf: 17.1 × 12.2 cm (6¾ × 4¹³⁄₁₆ in.)
Ms. Ludwig IX 9; 83.ML.105

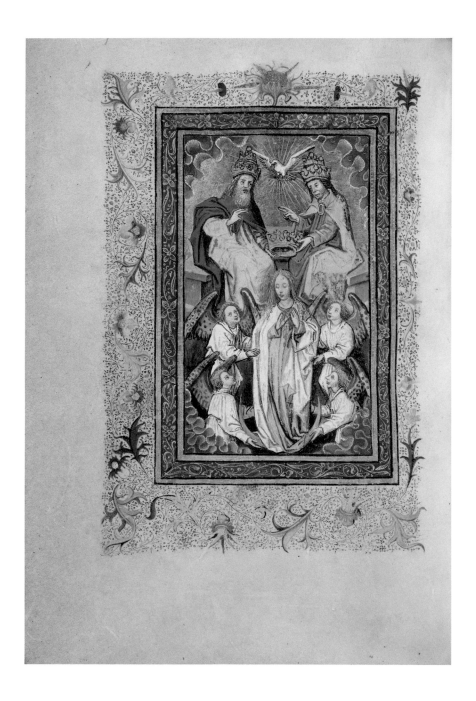

The Coronation of the Virgin by the Trinity

Book of hours, use of Utrecht, fol. 15v
Possibly Brabant, after 1460

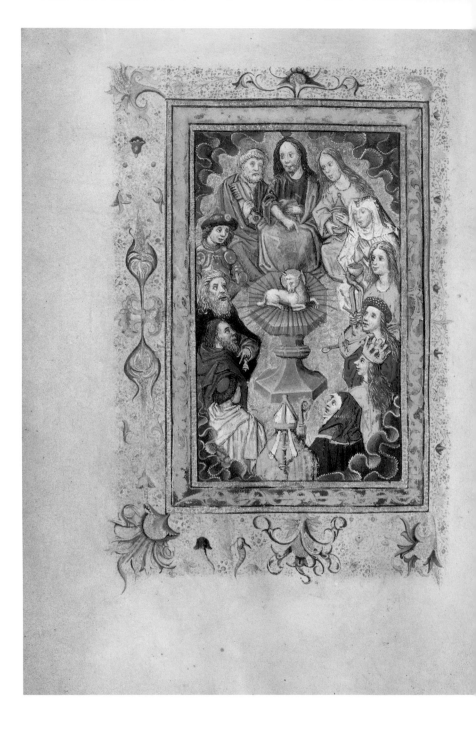

The Lamb of God Adored by Saints (left); Initial M: Salvator Mundi (right)

Book of hours, use of Utrecht,
fols. 99v–100
Possibly Brabant, after 1460

Hier beghint dat ghetide van
der ewigher wijsheit ons here.
Jne zie
le keret
di be
gheert
inden
nacht
ende in
minen gheeste inden muersten
muins herten soe heb ick uwe
ghewaket tot di. O alre claer
ste ewighe wijsheit ic bidde
dat dine begheerte toghen wer
dicheit moet ned:muen allen
wrende dingten vut myure

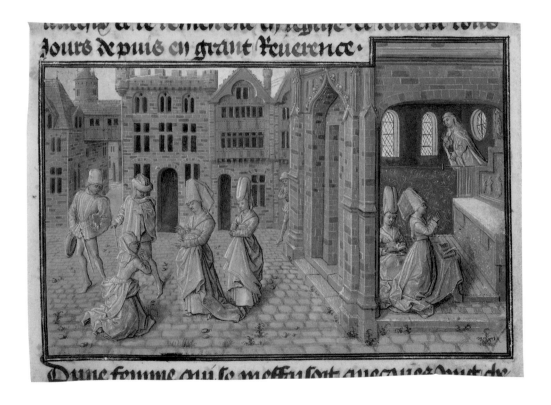

Lieven van Lathem | The Miracle of the Adulterous Woman's Repentance

Cutting from Jean Miélot,
Les Miracles de Nostre Dame
Ghent, ca. 1460
Cutting: 13.2 × 17.8 cm (5 3/16 × 7 in.)
Ms. 103; 2009.41

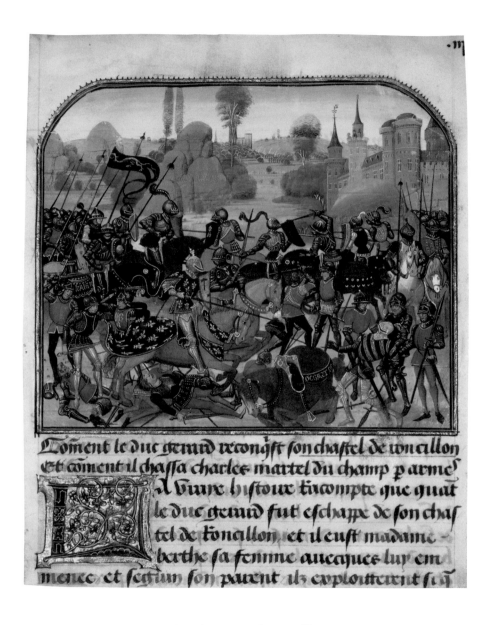

Loyset Liédet | Charles Martel Strikes Girart de Roussillon
from His Saddle before the Castle of Roussillon

*Cutting from Histoire de Charles
Martel, leaf 3*
Written out in Brussels, 1463–65,
illuminated in Bruges, 1467–72
Cutting: 23.3 × 18.9 cm (9³⁄₁₆ × 7⁷⁄₁₆ in.)
Ms. Ludwig XIII 6; 83.MP.149

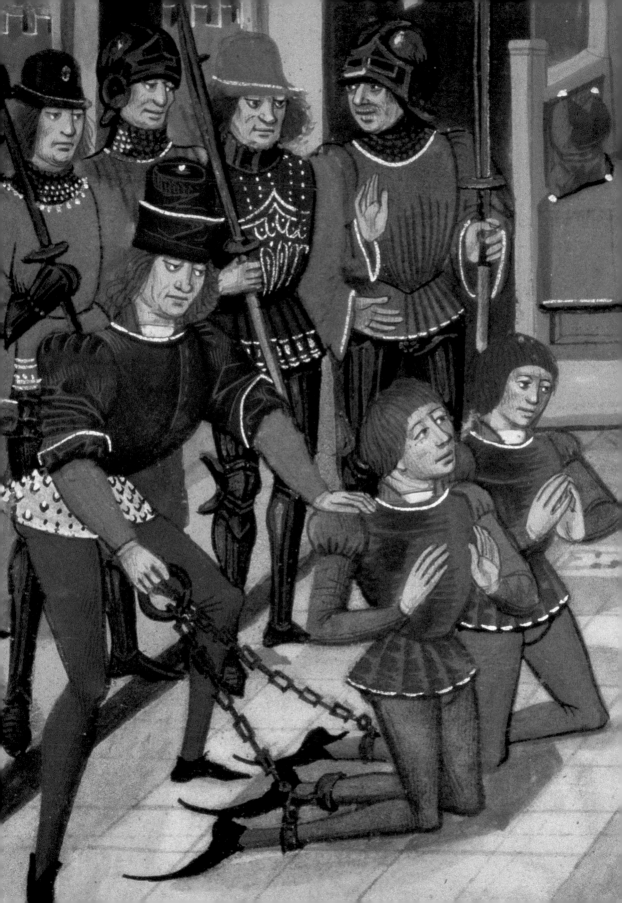

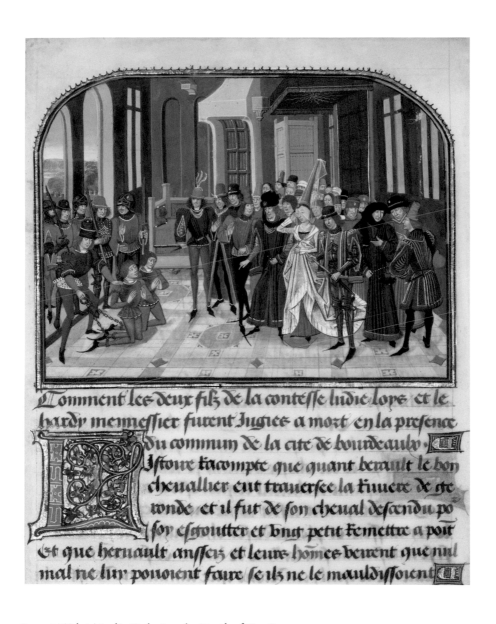

Loyset Liédet | Lydia Ordering the Death of Her Sons

Cutting from Histoire de Charles Martel, leaf 12 (above) and detail (left)
Cutting: 23.5 × 19.1 cm (9¼ × 7½ in.)

Willem Vrelant | The Annunciation

Arenberg Hours, use of Sarum, fol. 58
Bruges, early 1460s
Leaf: 25.6 × 17.3 cm
(10 1/16 × 6 13/16 in.)
Ms. Ludwig IX 8; 83.ML.104

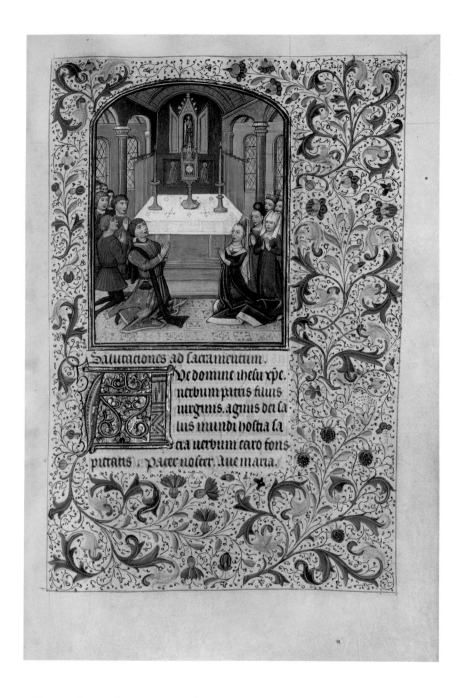

Willem Vrelant | The Adoration of the Eucharist

Arenberg Hours, use of Sarum,
fol. 144
Bruges, early 1460s

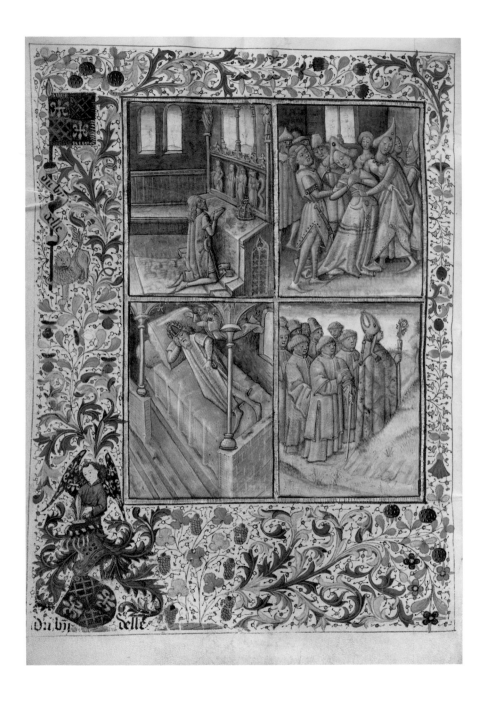

Master of the Brussels Roméléon | The Story of Emperor Constantine, His Daughter Sophia, and Bishop Theophilus

Invention et translation du corps de Saint Antoine, fol. 10v
Brussels or Bruges, ca. 1465–70
Leaf: 24.8 × 17.6 cm (9¾ × 6¹⁵⁄₁₆ in.)
Ms. Ludwig XI 8; 83.MN.127

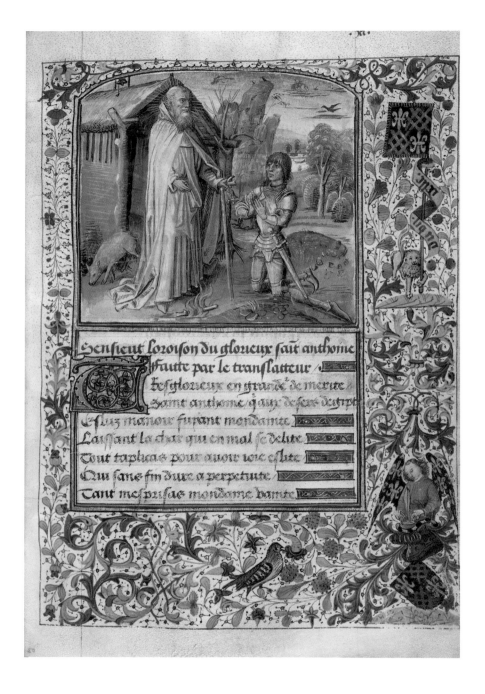

Dreux Jean or Workshop | **A Knight in Prayer before Saint Anthony Abbot**

Invention et translation du corps
de Saint Antoine, fol. 50
Brussels or Bruges, ca. 1465–70

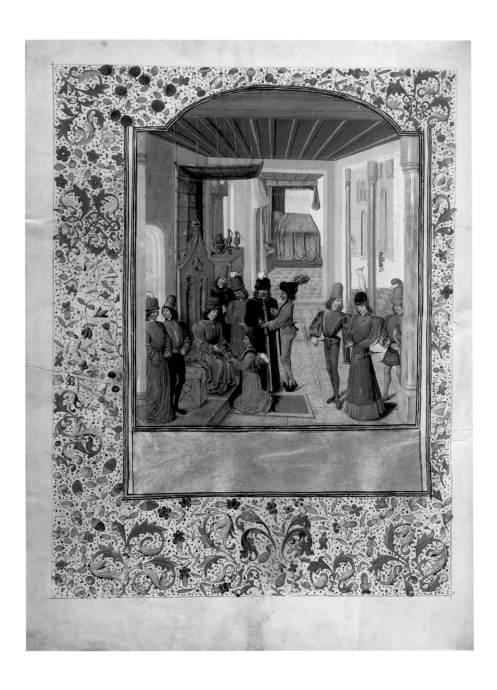

**Master of the Jardin de vertueuse consolation | Vasco da Lucena
Presents His Text to Charles the Bold**

Quintus Curtius Rufus,
Livre des fais d'Alexandre le grant
(translation by Vasco da Lucena),
fol. 2v
Written out by Jean du Quesne
Bruges and Lille, ca. 1470–75

Leaf: 43.2 × 33 cm (17 × 13 in.)
Ms. Ludwig XV 8; 83.MR.178

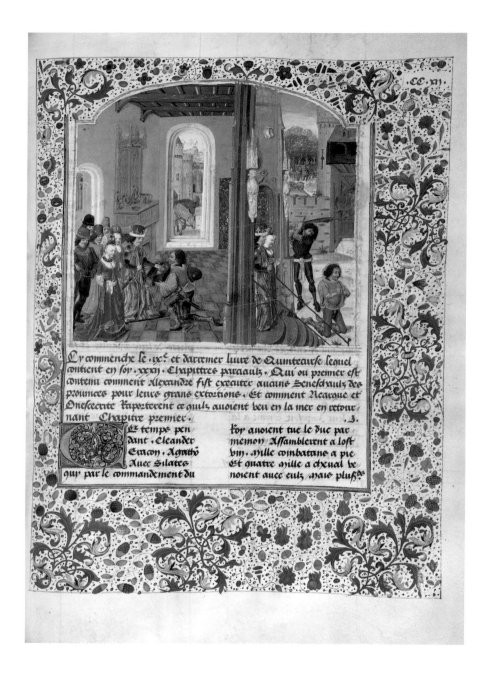

Master of the Jardin de vertueuse consolation | Orsines Presents a Gift to Alexander;
The Execution of Orsines

Quintus Curtius Rufus,
Livre des fais d'Alexandre le grant,
fol. 226
Bruges and Lille, ca. 1470–75

Lieven van Lathem | Decorated text page

Prayer Book of Charles the Bold,
fol. 30v (above) and detail (right)
Written out by Nicolas Spierinc
Ghent and Antwerp, 1469
and ca. 1471
Leaf: 12.4 × 9.2 cm (4⅞ × 3⅝ in.)
Ms. 37; 89.ML.35

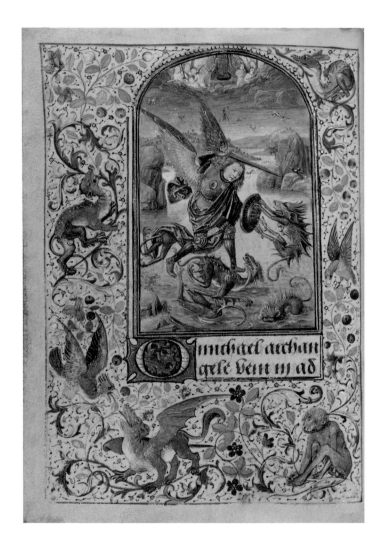

Lieven van Lathem | Saint Michael and the Dragon

Prayer Book of Charles the Bold,
fol. 15v
Ghent and Antwerp, 1469
and ca. 1471

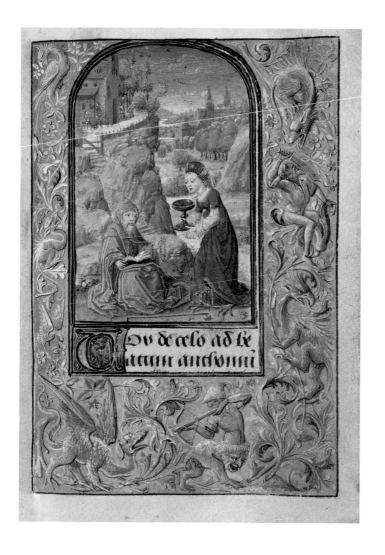

Lieven van Lathem | The Temptation of Saint Anthony

Prayer Book of Charles the Bold,
fol. 33
Ghent and Antwerp, 1469
and ca. 1471

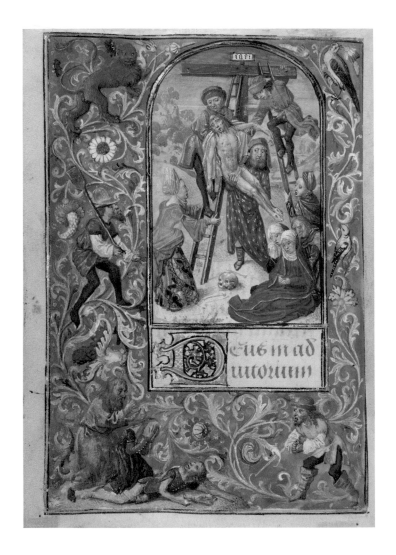

Vienna Master of Mary of Burgundy | The Deposition

Prayer Book of Charles the Bold,
fol. 111v
Ghent and Antwerp, 1469
and ca. 1471

confuz. et delaisserent leur propoz
et sen alerent en diuerses regions
selon la diuersite de leurs langues
Les filz de sem demouerent en
ase. Les filz de cham en auffrique
Et les filz de japhet en europe.
ysidorus dist que le monde est de
uise en troie parties. non pas
egaulz. Car il dist que ase com
mence de midi par deuers orient
iusques a septentrion. Et europe
comence de septentrion iusques
en occident. Et auffrique comece

de occident iusques a midi. Et
ainsi ase tient la mottie du monde
Et europe et auffrique contiennet
toute lautre. Et sont ces deux
parties si faictes que la tresgrant
mer entre entre deux et les deux
se sieue de lautre.
En cest chapitle deuise de la terre
dase. et comment elle est assise.
Et de paradis terrestre qui est
son premier bout. si comme les
escripture dist.
Lpij.

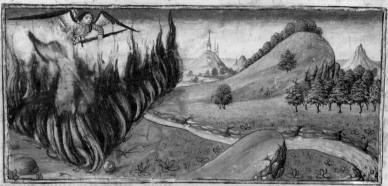

se sunommee du
nom dune femme
qui auoit nom. Ase
qui tint anchennement lempire
dorient. Et est ase ordonnee en la
tierce partie du monde. Et comen
ce en orient. et dure par deuers
midi iusques en la grant mer.
et fenist en nostre mer par deue
occident. et par deuers septentri
on fenist ou lac meothidien. et
ou fleuue de thanay. Et ceste
partie a moult de regions et de
prouinces. Et le comencement
est en paradis. Et paradis est

autant a dire comme lieu de de
lices. et est es parties dorient. Et
cellieu est plain de toutes mani
eres de bois portans fruit. et y est
le fust de vie. Il ny fait trop chault
ne trop froit. et y est lair trop a
tempre. Et ou milieu sourt une
fontaine qui arrouse tout le lieu.
et est celle fontaine deuisee en iiij
fleuues. Et lentree de cellui lieu
est denee a tous des que adam
ot dedens peche. Et est chaint
tout entour de mur de feu flam
bant. et samble que celle flambe
iomgne iusques au ciel. Et

The Angel Protecting the Earthly Paradise with a Wall of Flames

Vincent of Beauvais, *Miroir
historial* (translation by Jean de
Vignay), *vol. 1, fol. 54v*
Ghent, ca. 1475
Leaf: 43.8 × 30.5 cm (17¼ × 12 in.)
Ms. Ludwig XIII 5; 83.MP.148

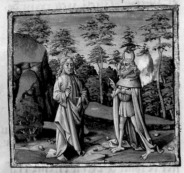

The First Temptation of Christ

Vincent of Beauvais,
Miroir historial, vol. 1, fol. 155v
Ghent, ca. 1475

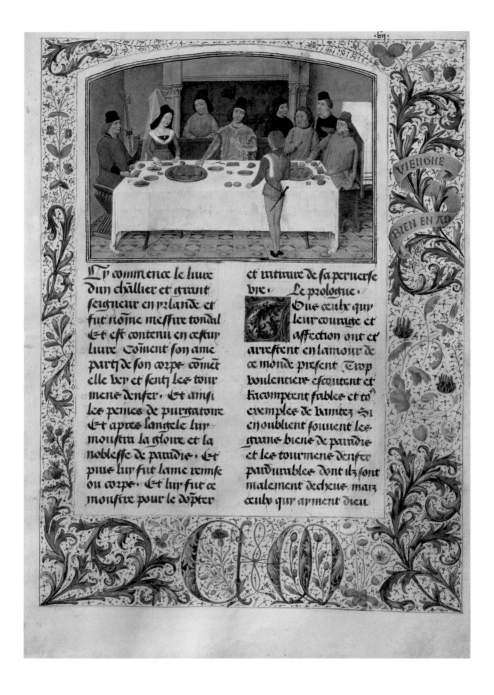

Simon Marmion | Tondal Suffers a Seizure at Dinner

Les visions du chevalier Tondal,
fol. 7
Written out by David Aubert
Ghent and Valenciennes, 1475
Leaf: 36.3 × 26.2 cm
(14 5/16 × 10 5/16 in.)
Ms. 30; 87.MN.141

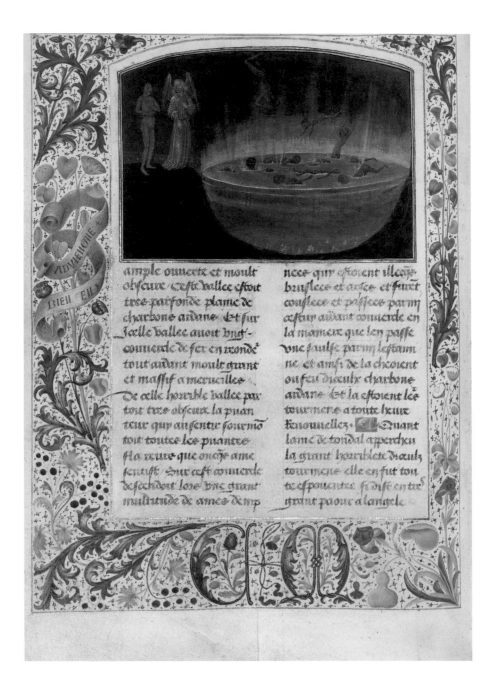

Simon Marmion | The Valley of Homicides: The Torment of Murderers

Les visions du chevalier Tondal,
fol. 13v
Ghent and Valenciennes, 1475

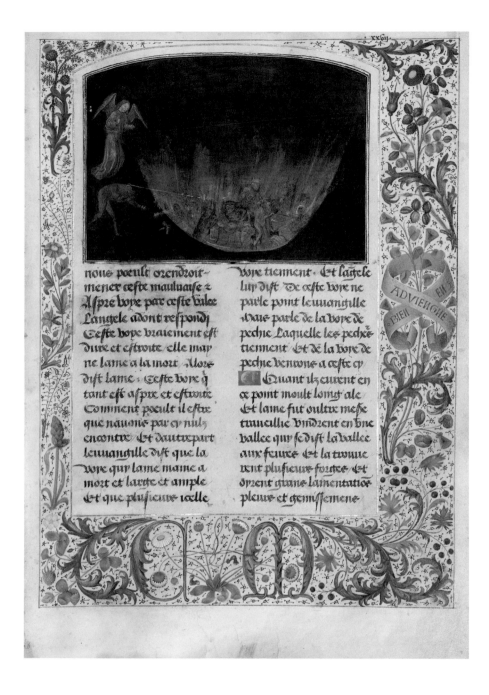

Simon Marmion | **The Valley of Fires: For Those Who Commit Evil upon Evil**

Les visions du chevalier Tondal,
fol. 27
Ghent and Valenciennes, 1475

Simon Marmion | The Happy Crowds of the Faithfully Married

*Les visions du chevalier Tondal,
fol. 37*
Ghent and Valenciennes, 1475

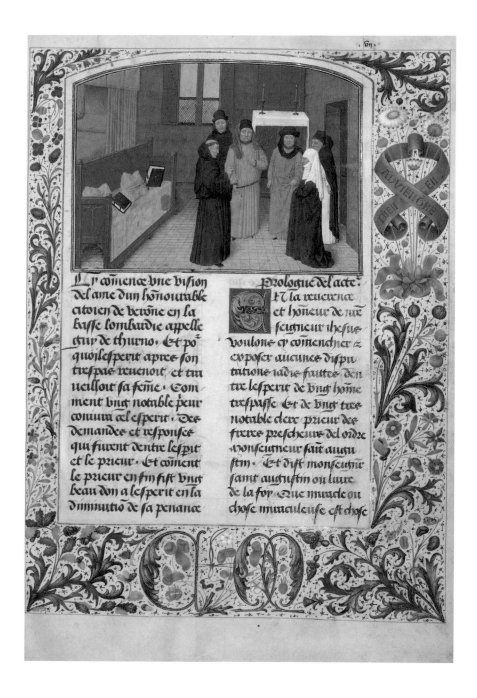

Simon Marmion | A Priest and Guy's Widow Conversing with the Soul of Guy de Thurno

La vision de l'âme de Guy de Thurno,
fol. 7
Written out by David Aubert
Ghent and Valenciennes, 1475
Leaf: 36.4 × 25.7 cm (14⁵⁄₁₆ × 10⅛ in.)
Ms. 31; 87.MN.152

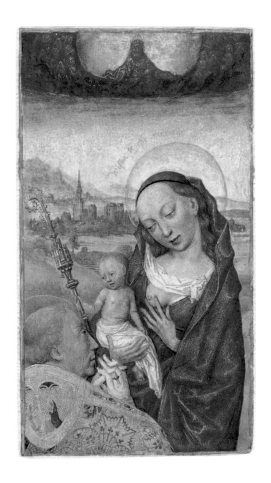

Simon Marmion | Saint Bernard's Vision of the Virgin and Child

Miniature from a devotional book
Valenciennes, ca. 1475–80
Leaf: 11.6 × 6.3 cm (4 9/16 × 2 1/2 in.)
Ms. 32; 88.MS.14

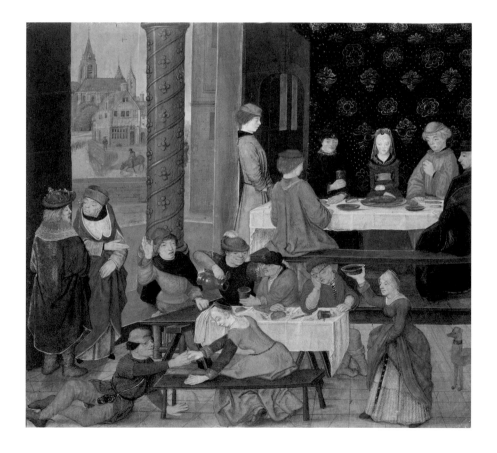

Master of the Dresden Prayer Book | The Temperate and the Intemperate

Miniature from Valerius Maxlmus,
Faits et dits mémorables des romains
(translation by Simon de Hesdin
and Nicolas de Gonesse)
Bruges, ca. 1475–80
Leaf: 17.5 × 19.4 cm (6⅞ × 7⅝ in.)
Ms. 43; 91.ms.81

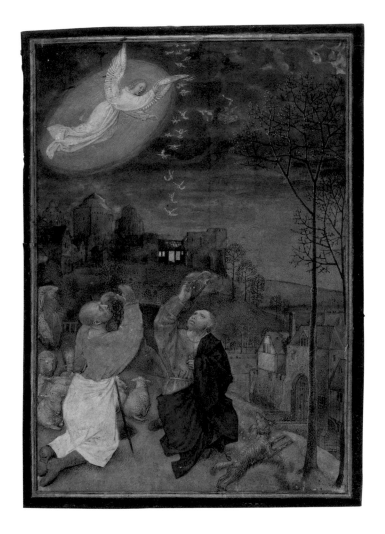

Master of the Houghton Miniatures | The Annunciation to the Shepherds

*Miniature from Emerson-White
Hours* (above) and detail (right)
Ghent, late 1470s/early 1480s
(before 1482)
Leaf: 12.5 × 9 cm (4¹⁵⁄₁₆ × 3⁹⁄₁₆ in.)
Ms. 60; 95.ML.53

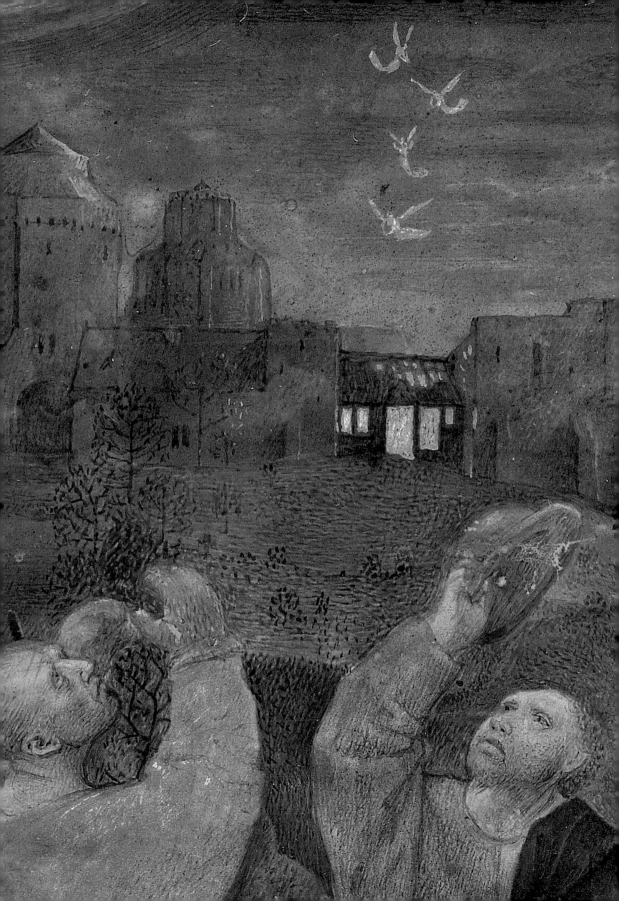

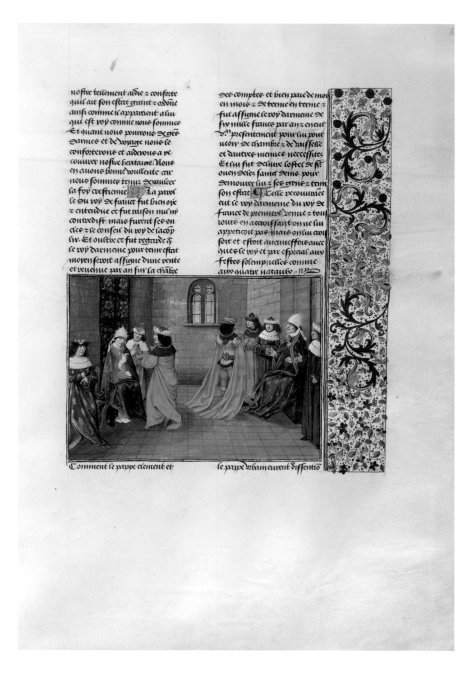

Master of the Getty Froissart | Pope Urban VI and the Anti-Pope Clement VII

Jean Froissart, *Chroniques,*
book 3, fol. 87
Bruges, ca. 1480–83
Leaf: 48 × 35 cm
(18⅞ × 13¾ in.)
Ms. Ludwig XIII 7; 83.MP.150

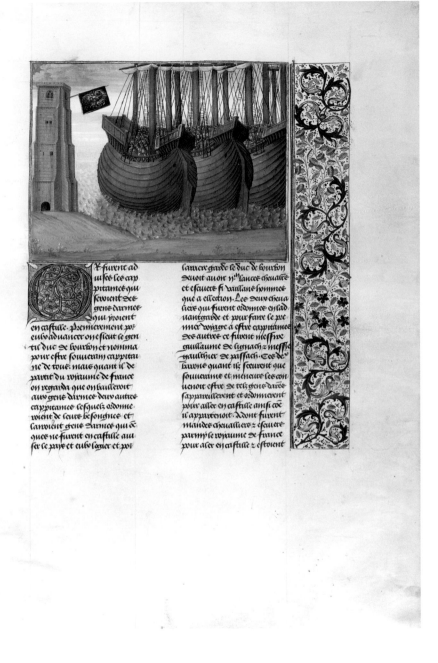

F furent ad
uisee lee cap
prtaines qui
seroient dee
grene darmee
qui yroient
en castille. Premierement pour
eulx aduancer on escleut se gen
til duc de bourbon et nomma
pour estre souuerain cappitai
ne de tout. mais quant il de
partit du royaume de france
on regarda que on vauldroit
aux gene darmee deux autres
cappitainee lesquels ordonne
roient de leure besoignee. et
sauroient grene darmee qui de
quee ne furent en castille aui
ser le pays et eulx seiner et pour

sauuer grade le duc de bourbon
deuoit auoir ij.M.lancee cheuatie
et escuere si vaillant hommee
que a ellection. Les deux cheua
liers qui furent ordonnee en sad
uantgarde et pour faire le pre
mier voiuere à estre cappitainee
dee autree ce furent messire
guillaume de signach z messire
gaulthier de passach. Tee de.
bourne quant ilz scouent que
souuerain et meneure lee con
uenoit estre de teli grnte duree
sappresserent et ordonnerent
pour aller en castille ainsi cõe
il appartenoit. Dont furent
mande cheualliere z escuere
parmy le royaume de france
pour aller en castille z estoient

Master of the Getty Froissart | **The Departure of the French Fleet for Castile**

Jean Froissart, *Chroniques,*
book 3, fol. 169
Bruges, ca. 1480–83

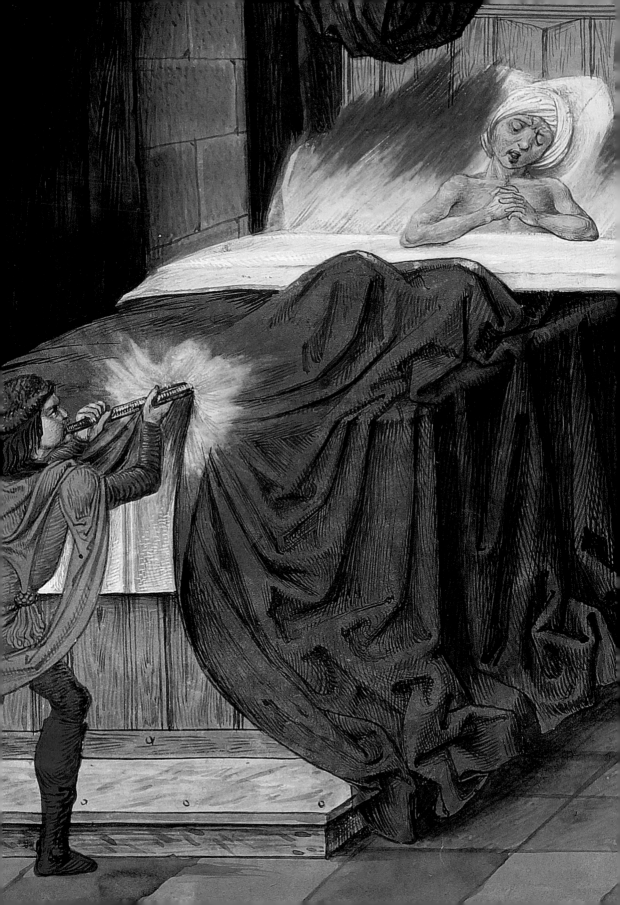

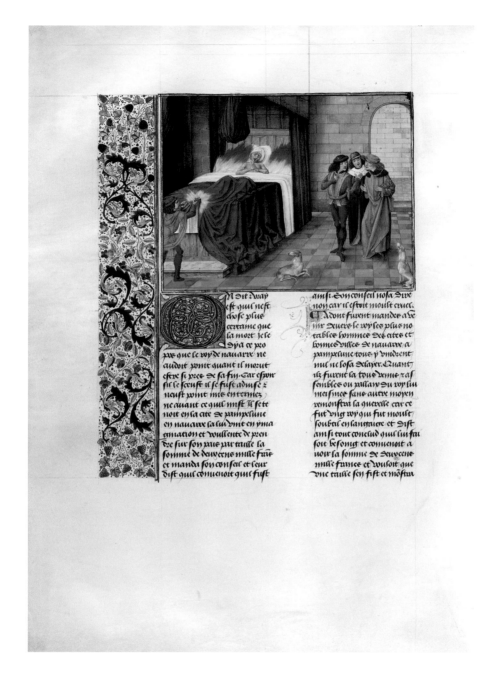

Master of the Getty Froissart | The Bed of the King of Navarre Set on Fire

Jean Froissart, *Chroniques,*
book 3, fol. 274v (above) and
detail (left)
Bruges, ca. 1480–83

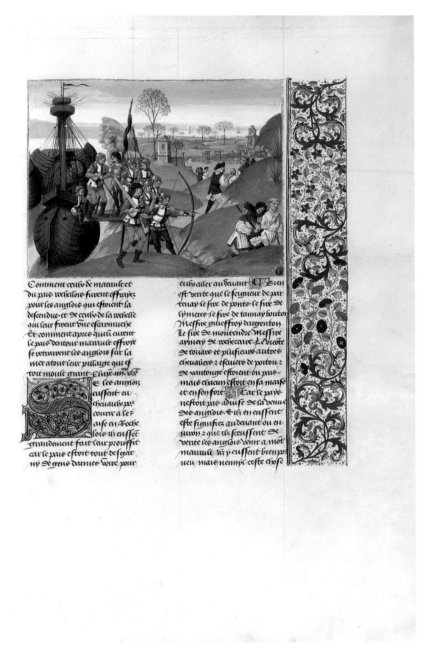

Comment ceulx de maruile et
du pue urseldie furent effuyez
pour les angloie qui estoient la
descendue. et de ceulx de la urseille
qui leur furent une escarmuche
et comment apres quilz eurent
le pais dentour maruile effouye
se retournent les angloie sur la
mer atout leur pillaige qui es-
toit moult grant. Et puis. m. uoÿ
⟨E⟩ les angloie
eussent eu
cheuaulx por
courir a le
aise en Roche
lle ilz eussent
grandement fait leur prouffit
car le pais estoit tout de grant
my de grene dames doulx pour

culx aller au deuant. Et bien
est uerite que le seigneur de par
tenay le sire de ponte. le sire de
sÿmere. le sire de tannay bouton
Messire gnlieffroÿ dargenton
le sire de montendre. Messire
armeÿ de uoheeaulx. Le uicote
de touare et plusieurs autres
cheualiers z escuers de poitou z
de saintonge estoient ou pais
mais chacun estoit en sa maison
et en son fort. Car se paÿs
nestoit pas aduise de la uenue
des angloie. Et ilz en eussent
este signifies au deuant ou en
uyron z que ilz seussent de
uerite les angloie uenir a mot
maruile. Ilz ÿ eussent bien ue-
ueu. mais nennÿ ceste chose

Master of the Getty Froissart | The English Besieging La Rochelle

Jean Froissart, *Chroniques,*
book 3, fol. 314
Bruges, ca. 1480–83

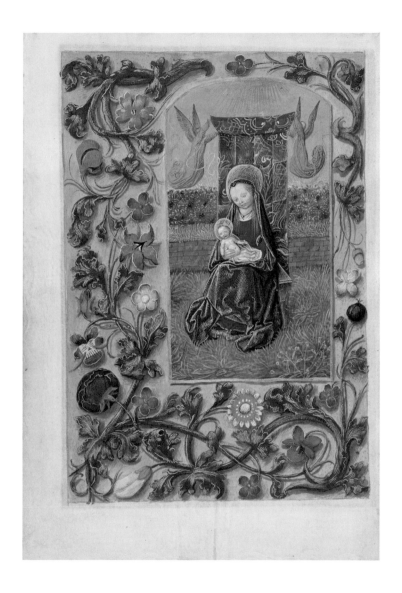

Master of the Dresden Prayer Book | **The Virgin and Child Enthroned**

Crohin-La Fontaine Hours,
use of Rome, fol. 29v
Bruges, 1480–85 (?)
Leaf: 13.3 × 9.4 cm (5¼ × 3¹¹⁄₁₆ in.)
Ms. 23; 86.ML.606

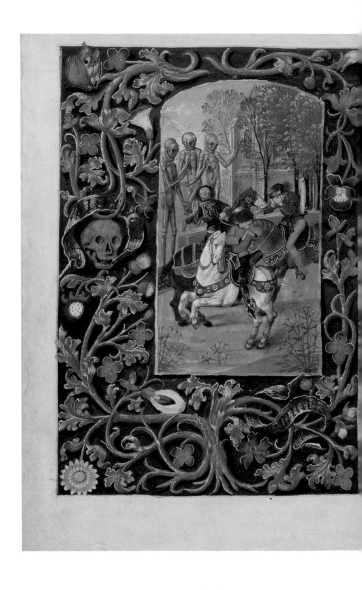

**Master of the Dresden Prayer Book | The Three Living and Three Dead (left);
Decorated Initial D (right)**

*Crohin-La Fontaine Hours,
use of Rome, fols. 146v–147*
Bruges, perhaps ca. 1480–85

147

97

**Text page containing Terce of the Hours of the Cross (incomplete)
with decorated border**

Leaf from a book of hours,
use of Cambrai
Flanders or northern France,
ca. 1480–90
Leaf: 12.4 × 9.2 cm (4⅞ × 3⅝ in.)
Ms. 45; 92.MS.34

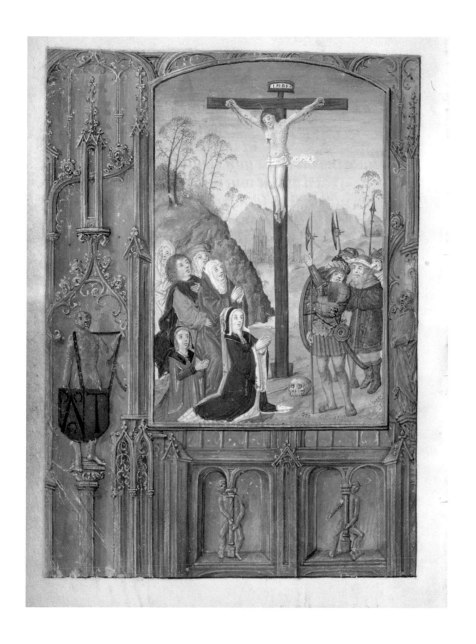

Workshop of the Master of James IV of Scotland (Gerard Horenbout?) |
The Crucifixion with the Patron

Book of hours, use of Utrecht,
fol. 86v
Written out in Cologne
Ghent, ca. 1500
Leaf: 15.2 × 11.1 cm (6 × 4⅜ in.)
Ms. Ludwig IX 17; 83.ML.113

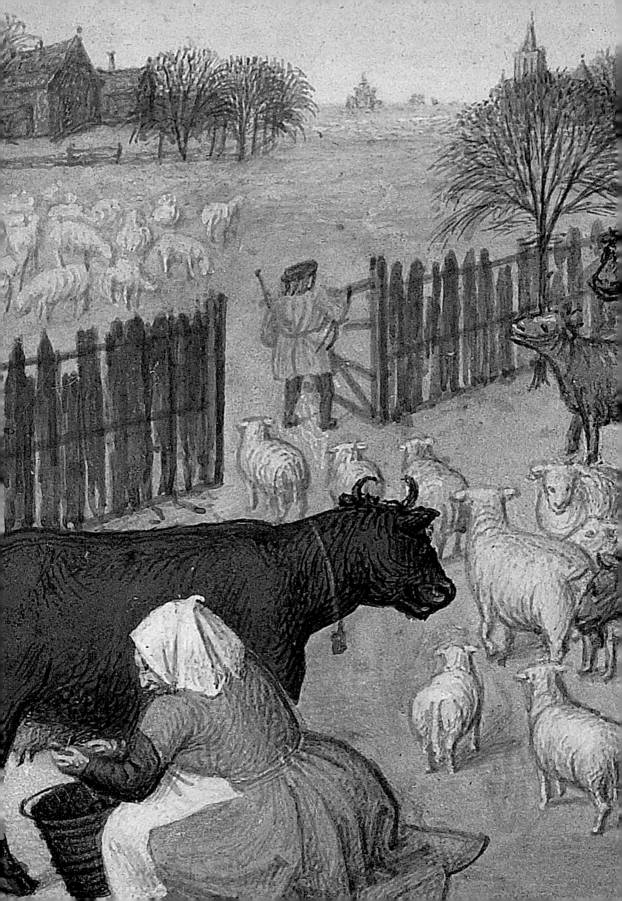

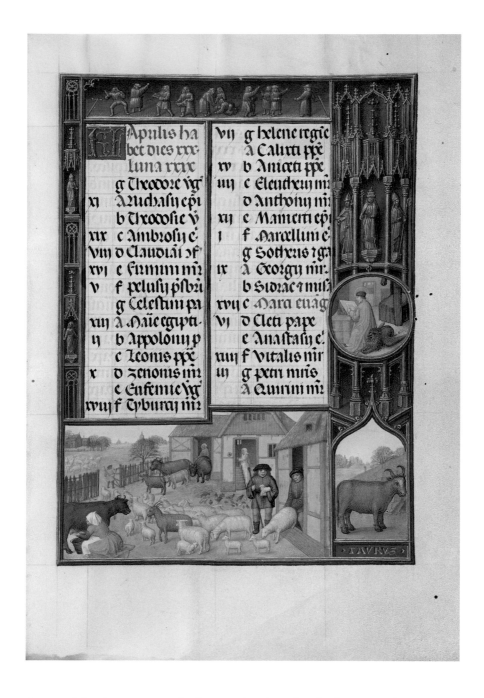

Master of the First Prayer Book of Maximilian | April: Calendar Page with Farm Animals, Milking, and Buttermaking

Spinola Hours, use of Rome,
fol. 3 (above) and detail (left)
Bruges and Ghent, ca. 1510–20
Leaf: 23.2 × 16.7 cm (9⅛ × 6⁹⁄₁₆ in.)
Ms. Ludwig IX 18; 83.ML.114

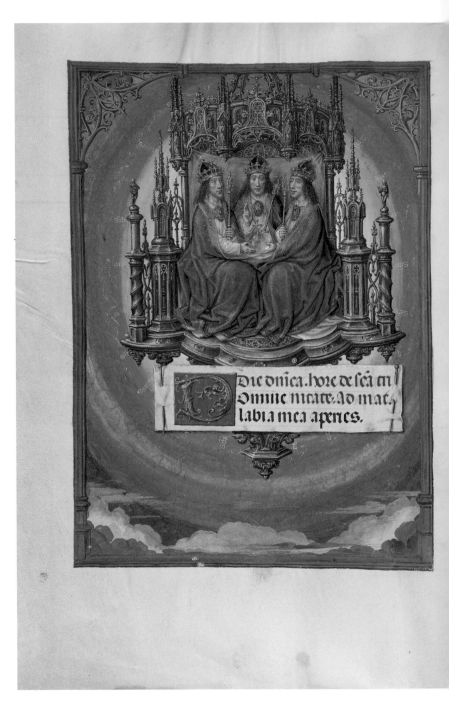

Master of James IV of Scotland (Gerard Horenbout?) | Holy Trinity Enthroned (left);
Abraham and the Three Angels (right)

Spinola Hours, use of Rome,
fols. 10v–11
Bruges and Ghent, ca. 1510–20

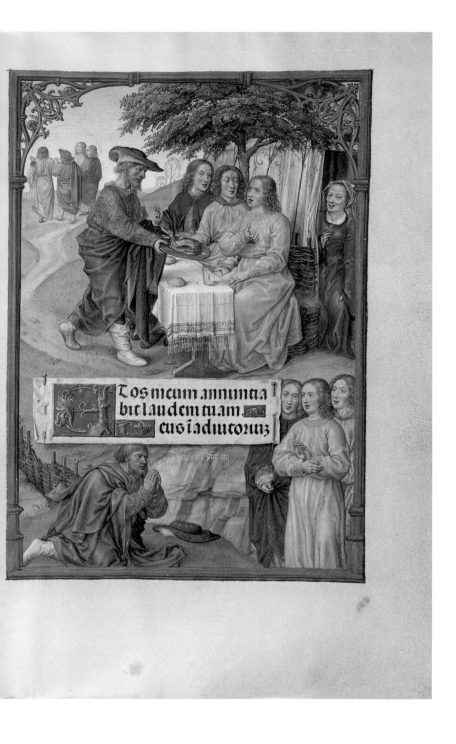

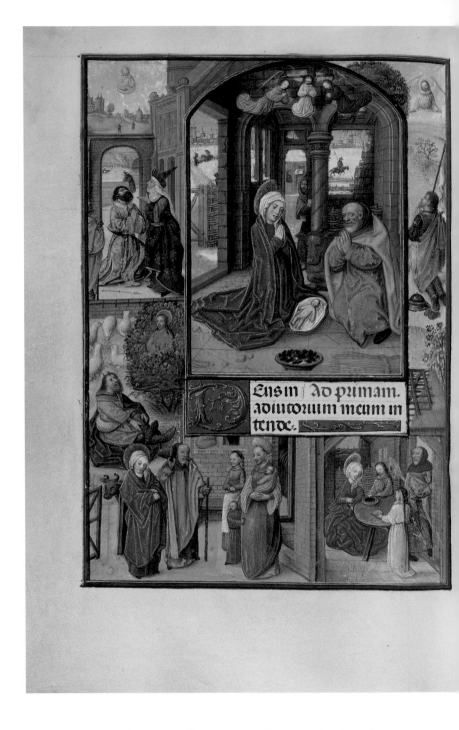

Master of the Dresden Prayer Book | The Nativity (left); Christ before Caiaphas (right)

*Spinola Hours, use of Rome,
fols. 119v–120*
Bruges and Ghent, ca. 1510–20

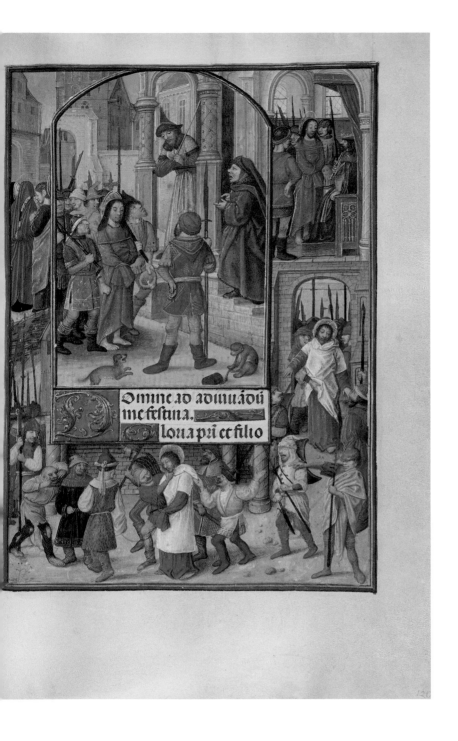

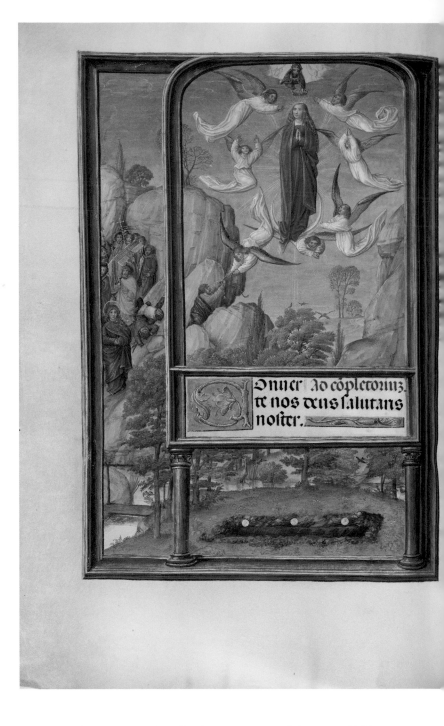

Master of James IV of Scotland (Gerard Horenbout?) | The Assumption of the Virgin (left); The Crucifixion (right)

Spinola Hours, use of Rome,
fols. 148v–149
Bruges and Ghent, ca. 1510–20

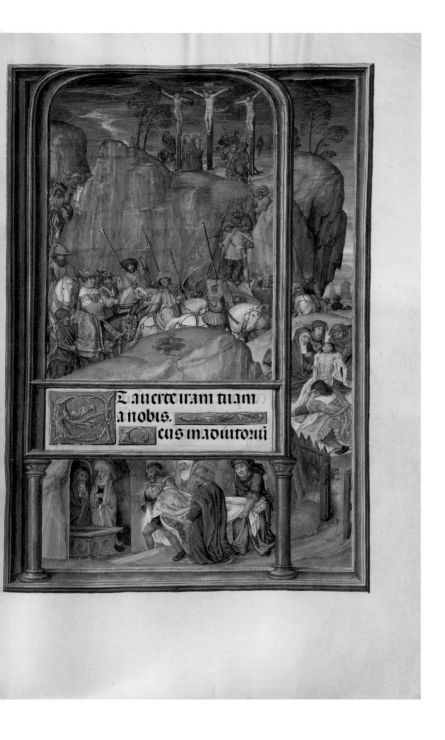

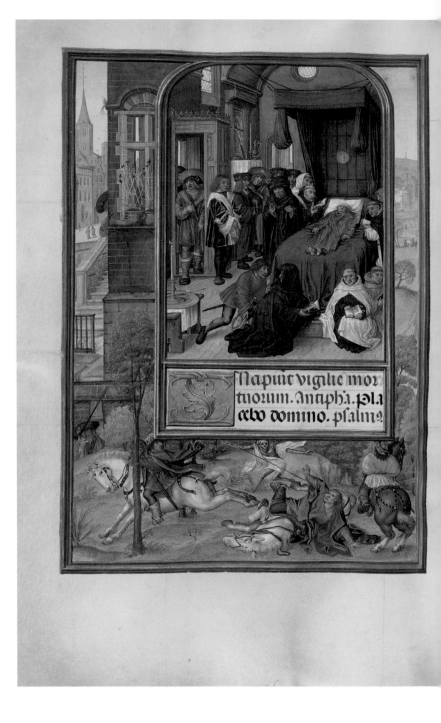

**Master of James IV of Scotland (Gerard Horenbout?) | Deathbed Scene (left);
Funeral Mass (right)**

*Spinola Hours, use of Rome,
fols. 184v–185*
Bruges and Ghent, ca. 1510–20

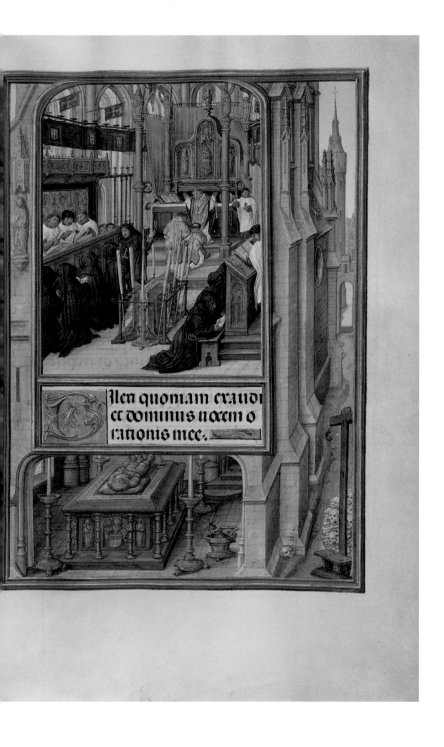

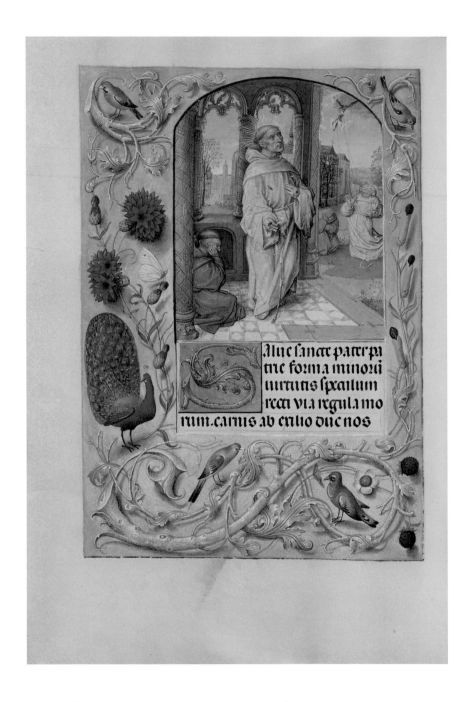

Master of the Lübeck Bible | The Stigmatization of Saint Francis

*Spinola Hours, use of Rome,
fol. 258v*
Bruges and Ghent, ca. 1510–20

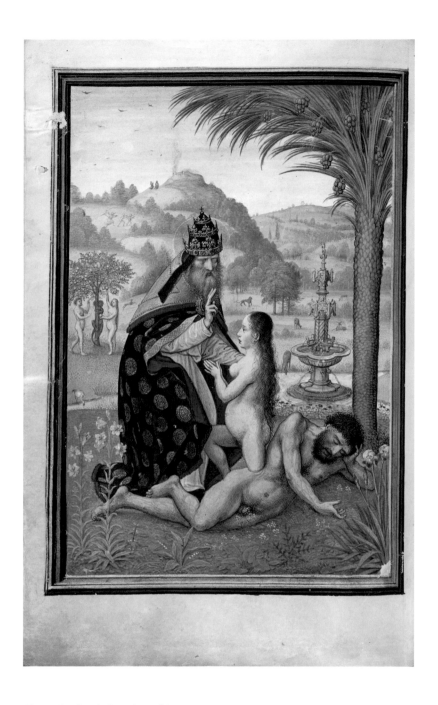

Simon Bening | Creation of Eve

*Prayer Book of Cardinal Albrecht
of Brandenburg, fol. 7v*
Bruges, ca. 1525–30
Leaf: 16.8 × 11.4 cm (6⅝ × 4½ in.)
Ms. Ludwig IX 19; 83.ML.115

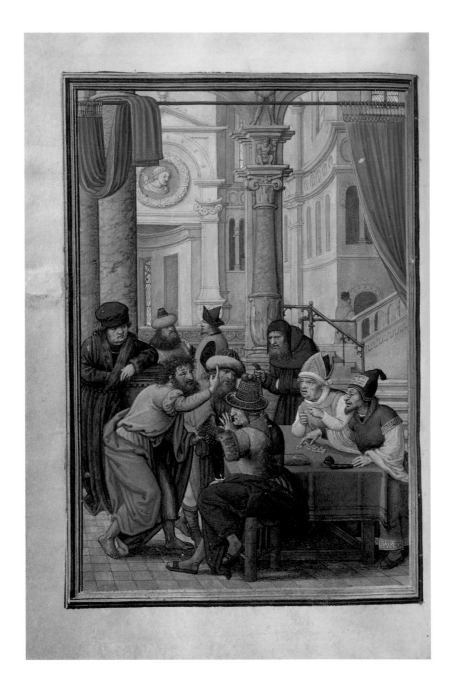

Simon Bening | Judas Receiving the Thirty Pieces of Silver

Prayer Book of Cardinal Albrecht
of Brandenburg, fol. 93v (above)
and detail (right)
Bruges, ca. 1525–30

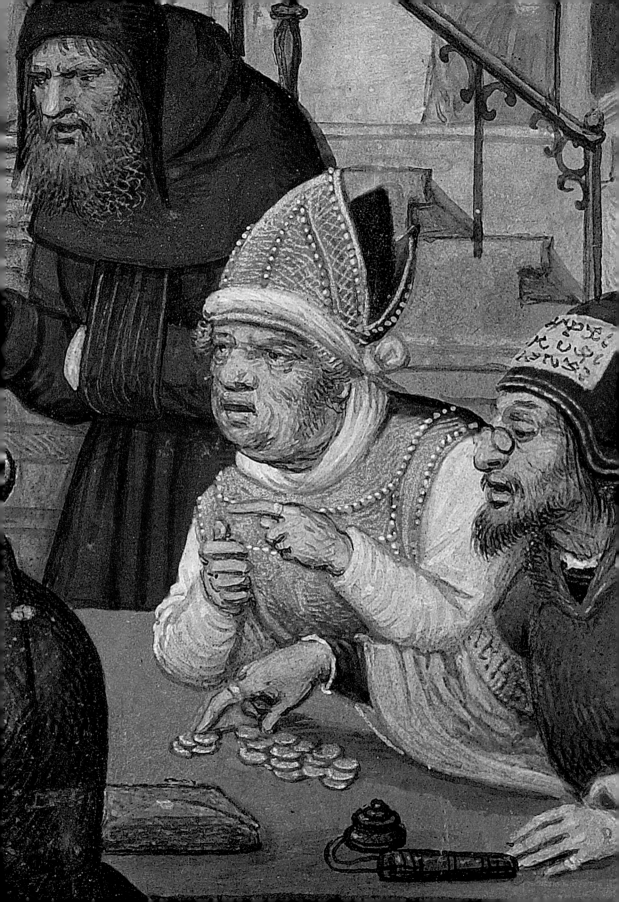

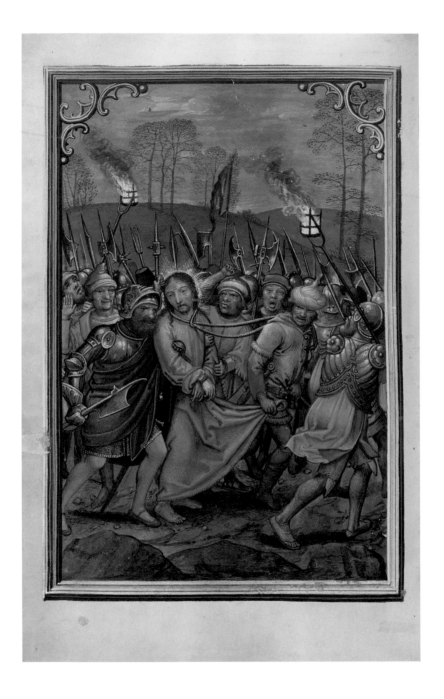

Simon Bening | **The Arrest of Christ**

Prayer Book of Cardinal Albrecht
of Brandenburg, fol. 107v
Bruges, ca. 1525–30

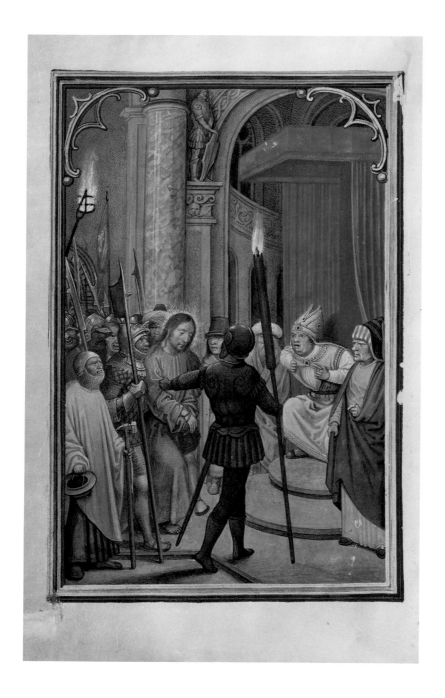

Simon Bening | **Christ before Caiaphas**

*Prayer Book of Cardinal Albrecht
of Brandenburg, fol. 128v*
Bruges, ca. 1525–30

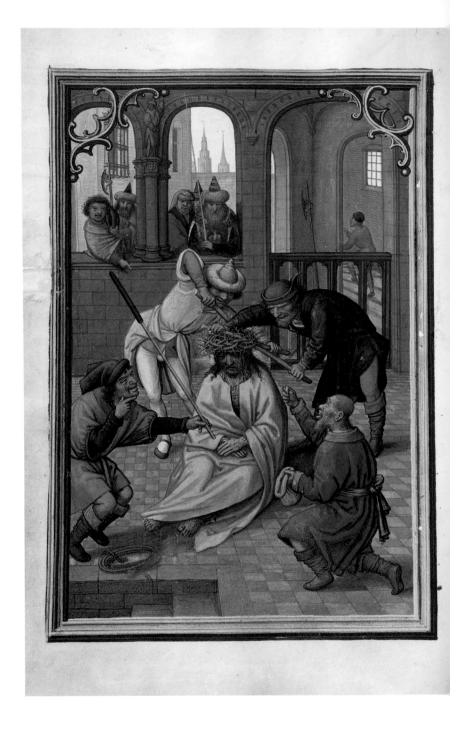

Simon Bening | The Crowning with Thorns (left); Historiated border
with Shimei Throwing Stones at David (right)

Prayer Book of Cardinal Albrecht
of Brandenburg, fols. 160v–161
Bruges, ca. 1525–30

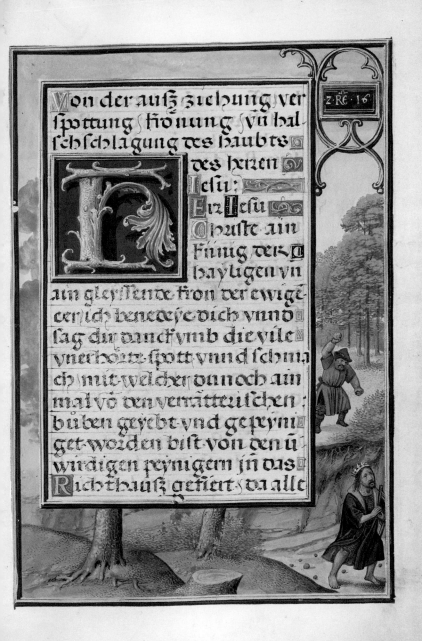

Von der auß ziehung, ver
spottung, kronung, vñ hal
schschlagung des haubts
des herren
Jesu;
Err Jesu
Christe, ain
künig der
hayligen vnd
ain gleyssende kron der ewigē
cen, ich benedeye dich vnnd
sag dir danck vmb die vile
vnerhorte spott vnnd schma
ch, mit welcher du noch ain
mal vō den verrätterischen,
büben geycbt vnd gepyni
get worden bist von den ü
wirdigen peynigern jn das
Richthauß gefiert, da alle

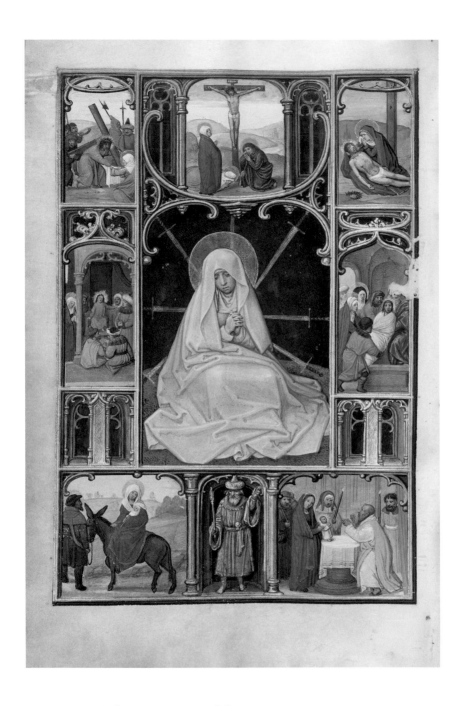

Simon Bening | The Seven Sorrows of the Virgin

*Prayer Book of Cardinal Albrecht
of Brandenburg, fol. 251v*
Bruges, ca. 1525–30

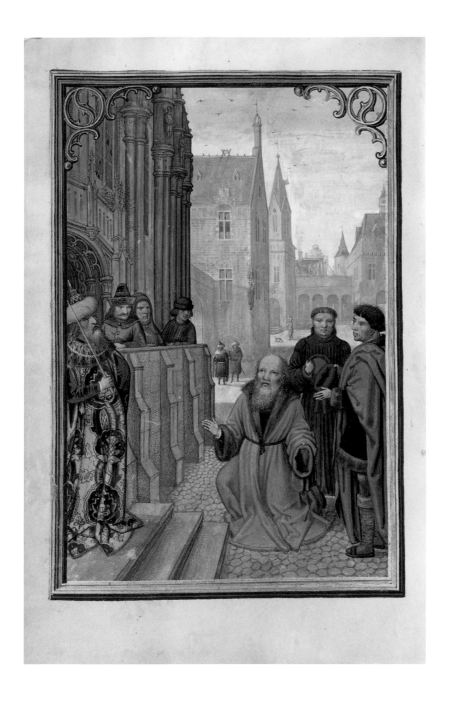

Simon Bening | Joseph of Arimathea before Pilate

Prayer Book of Cardinal Albrecht
of Brandenburg, fol. 311v
Bruges, ca. 1525–30

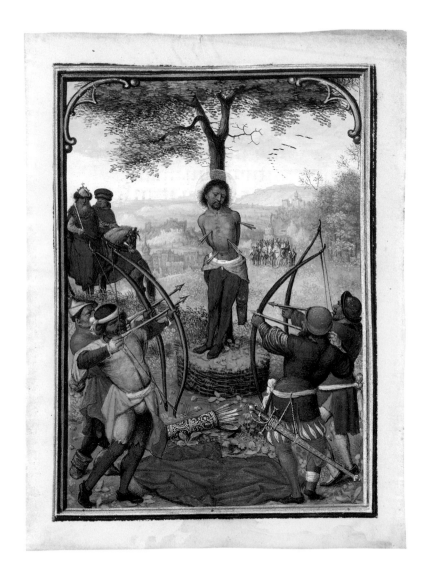

Simon Bening | The Martyrdom of Saint Sebastian

Leaf from Munich-Montserrat Hours
Bruges, ca. 1535–40
Leaf: 13.7 × 10 cm (5 3/8 × 3 15/16 in.)
Ms. 3; 84.ML.83, leaf 2

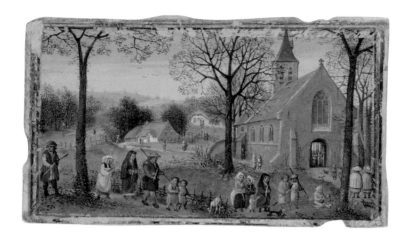

Simon Bening | Villagers on Their Way to Church (February)

Calendar bas-de-page miniature
from a book of hours, recto
Bruges, ca. 1550
Leaf: 5.6 × 9.5 cm (2 3/16 × 3 3/4 in.)
Ms. 50; 93.MS.19

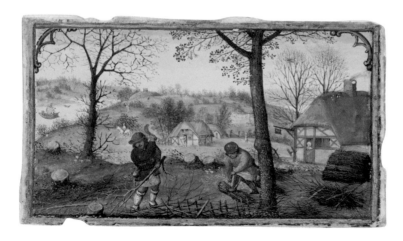

Simon Bening | Gathering Twigs (March)

Calendar bas-de-page miniature
from a book of hours, verso
Bruges, ca. 1550

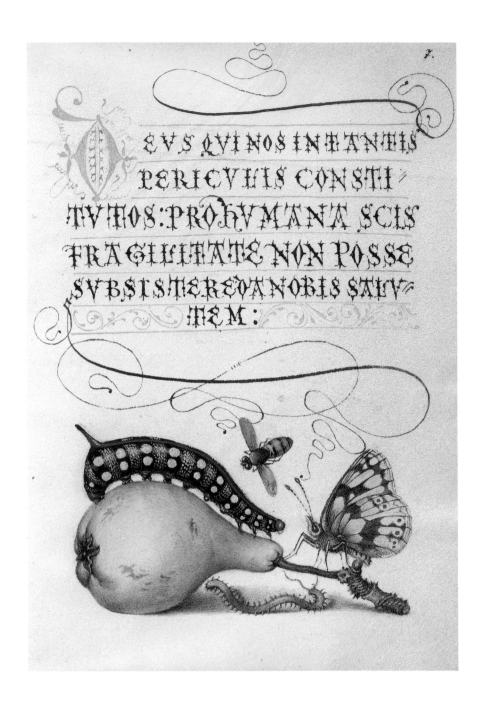

Joris Hoefnagel | Hoverfly, Horntail Caterpillar of Spurge Hawk-Moth, Pear, Marbled White, and Centipede

Mira calligraphiae monumenta, fol. 7
Vienna, written out by Georg
Bocskay, 1561–62, illuminated
ca. 1591–96
Leaf: 16.6 × 12.4 cm (6 9/16 × 4 7/8 in.)
Ms. 20; 86.MV.527

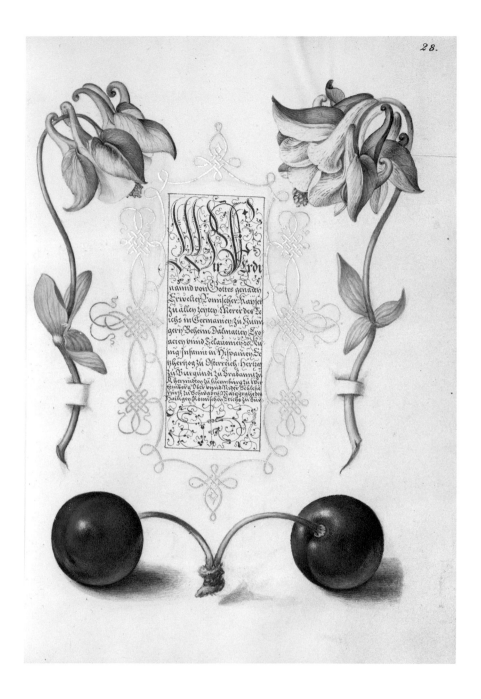

Joris Hoefnagel | European Columbines and Sweet Cherry

Mira calligraphiae monumenta,
fol. 28
Vienna, written out by Georg
Bocskay, 1561–62, illuminated
ca. 1591–96

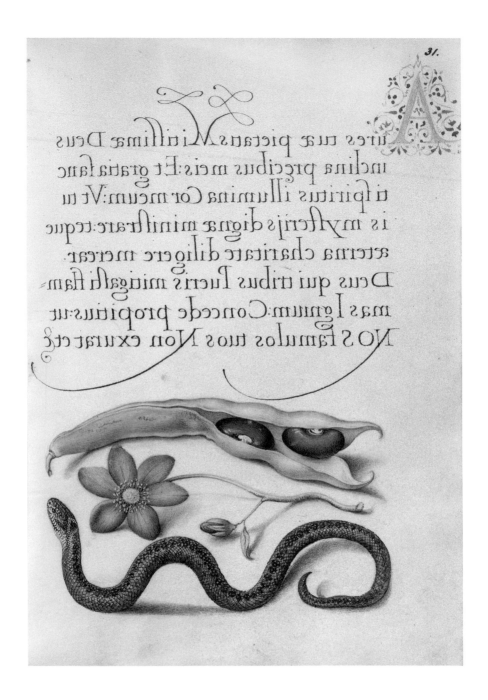

Joris Hoefnagel | Kidney Bean, Poppy Anemone, Adder,
and Mirror Writing

Mira calligraphiae monumenta,
fol. 31
Vienna, written out by Georg
Bocskay, 1561–62, illuminated
ca. 1591–96

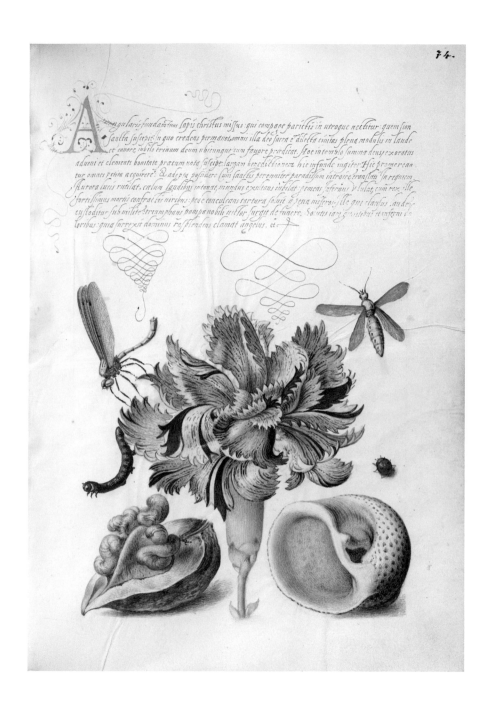

Joris Hoefnagel | Damselfly, Carnation, Insect, Caterpillar, Ladybird, English Walnut, and Marine Mollusk

Mira calligraphiae monumenta,
fol. 74
Vienna, written out by Georg
Bocskay, 1561–62, illuminated
ca. 1591–96

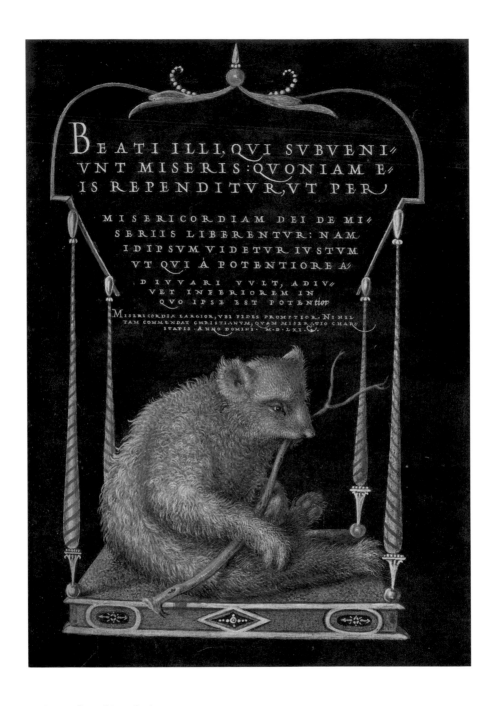

Joris Hoefnagel | A Sloth

Mira calligraphiae monumenta,
fol. 106
Vienna, written out by Georg
Bocskay, 1561–62, illuminated
ca. 1591–96

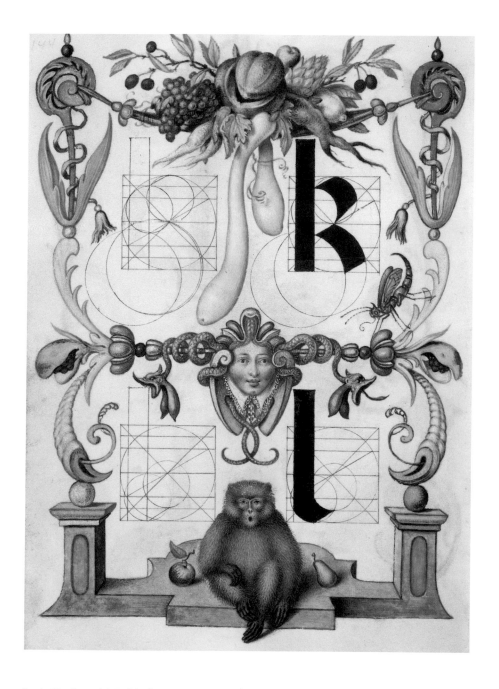

Joris Hoefnagel | Guide for Constructing the Lowercase Letters k and l

Mira calligraphiae monumenta,
fol. 144v
Vienna, 1596

© 2010 J. Paul Getty Trust

Published by the J. Paul Getty Museum

Getty Publications
1200 Getty Center Drive, Suite 500
Los Angeles, California 90049-1682
www.gettypublications.org

Gregory M. Britton, *Publisher*

Beatrice Hohenegger, *Editor*
Robin Ray, *Manuscript Editor*
Vickie Sawyer Karten, *Series Designer*
Jeffrey Cohen, *Designer*
Amita Molloy, *Production Coordinator*

Photography and digital imaging supplied by
Stanley Smith, Rebecca Vera-Martinez, Michael Smith,
and Johana Herrera of Getty Imaging Services

Color separations by Professional Graphics Inc.,
Rockford, Illinois
Printed and bound by CS Graphics Pte Ltd., Singapore

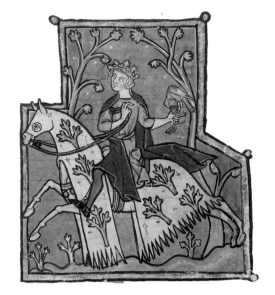

Library of Congress Cataloging-in-Publication Data
J. Paul Getty Museum.
 Illuminated manuscripts from Belgium and the Netherlands
in the J. Paul Getty Museum / Thomas Kren.
 p. cm.
 ISBN 978-1-60606-014-8 (pbk.)
 1. Illumination of books and manuscripts—Belgium—Catalogs. 2. Illumination of
books and manuscripts—Netherlands—Catalogs. 3. Illumination of books and
manuscripts—California—Los Angeles—Catalogs. 4. J. Paul Getty Museum Catalogs.
I. Kren, Thomas, 1950– II. Title.
 ND3171.J24 2010
 745.6′70949207479494—dc22

 2009049861

Front cover: *Christ Blessing* (detail, page 50)
Back cover: *Holy Trinity Enthroned* (detail, page 102)
Frontispiece: *The English Besieging La Rochelle* (detail, page 94)
Page 4: *Saint Michael and the Dragon* (detail, page 76)
Page 6: *The Happy Crowds of the Faithfully Married* (detail, page 84)
Page 34: *Christ and a Monk with Animals* (detail, page 43)
Page 128: *May: Calendar Page with a Man Hawking* (detail, page 40)